TO MONA

SISTERS
BY
DAVID HAMILTON

TEXT
ALAIN ROBBE-GRILLET

NEW YORK
WILLIAM MORROW AND COMPANY, INC. 1973

SEMBLANCE

If one is alone,
perhaps it seems better to be two.
If one is two, better seeming to be three.
Beyond that, it is too complex,
even with many windows
and many mirrors of different shapes.
If one is more than three,
it would seem better to be one.

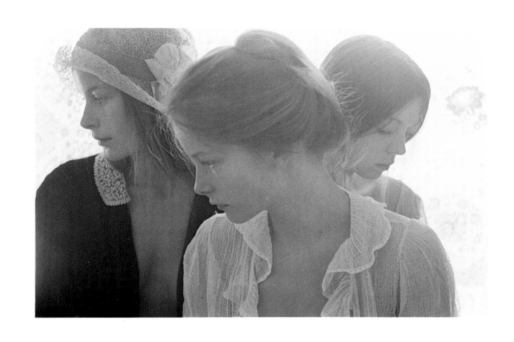

DUBIOUS IDENTITY

Perhaps you should resort to subterfuges,
such as wigs or things with which to paint
your lips, your eyes, or then, maybe put on a cloche hat
of lace and flowers,
a ridiculous sort of hat,
and assuming haughty and dreamy airs (can you keep a
straight face?), imitate the reflectiveness of someone
who has just received a sudden letter from afar,
from the Indies, or the Andes, or the Ondies,
from a country which does not exist,
a little blue letter telling of unbelievable things:
the tale of seven adolescents married by Giles of Retz,
the tale of twenty-four captive maidens ill in the subterranean
prison of Vanadium, that of the hundred twenty-one prostituted
maidens of the Blue Villa in Shanghai, or that of the nine
hundred ninety-nine nocturnal companions of King Salomon,
son of David;
or then it might be the tale of the eleven thousand virgins
of Cologne,
the tale, at any rate, of any number of young girls
who do not exist,
discreet as images and where the images multiply
from page to page, in a book you pretend to be seeing
for the first time.

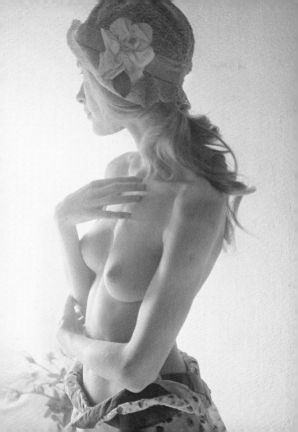

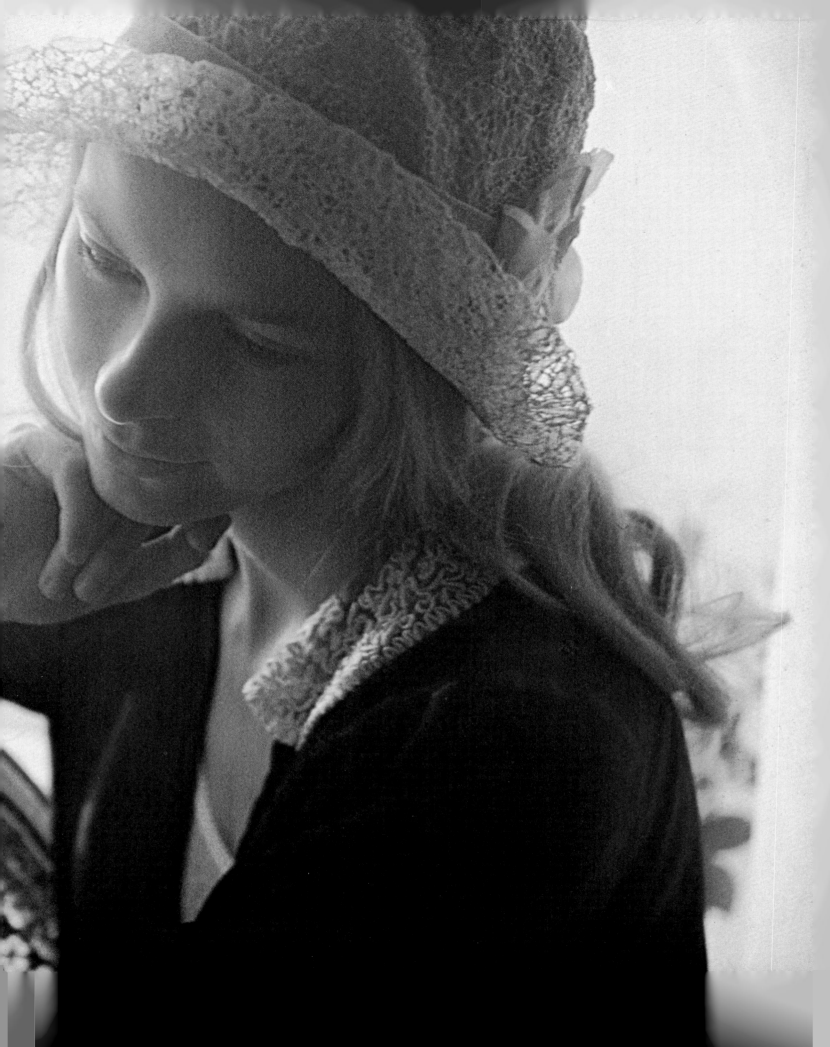

RULES OF THE GAME

Here is the way to play;
Look at yourselves together in a mirror, ever striving
to keep a vacant look in your eyes, as if
seeing something quite far off, something
of the uncertain and vaporous which slowly fades away in place.
Dress one another up, draping yourselves in bits of voile
too short or rent. Knot about your hips a swatch
of some improbable stuff. Make a gown from the curtains.
Dab one another with perfume, in all your fragile places,
one after the other in the same sequence (make no mistakes).
Read a stupid sonnet together.
Take on a terribly romantic air to say obscene things,
never ceasing to look at yourselves in the glass.
And then, each of you two, exchanging roles in turn,
feigns sleep while the other, having opened a book of poems
to the same page, rereads the text aloud, now and then
changing the words around.
Throughout the reading, your two bodies must touch at a single point,
as if by chance:
the tip of a foot in the hollow under an arm, or the hollow
of an elbow round the tip of a breast.
Transform anew the delusive text by replacing the flowery words
with crude terms for the secret parts of the feminine body,
so that it no longer makes any sense.
You might begin with names having the same number of letters
as the original word, then proceed to words
much too large or much too short.
And then, you go to the window,
you draw back the filmy drapery and look out into the beyond
saying to invisible witnesses: "She is an idiot. She understands
nothing. She sleeps like an overripe fruit."
Then come back toward the bed and whisper lowly into her ear,
saying clearly: "You are nothing but a little whore, a slut,
a damp meadow, a half-open shell." And then,
withdraw a bit to contemplate her
casting a pretty smile at her. But she does not even see it,
for she is truly asleep.

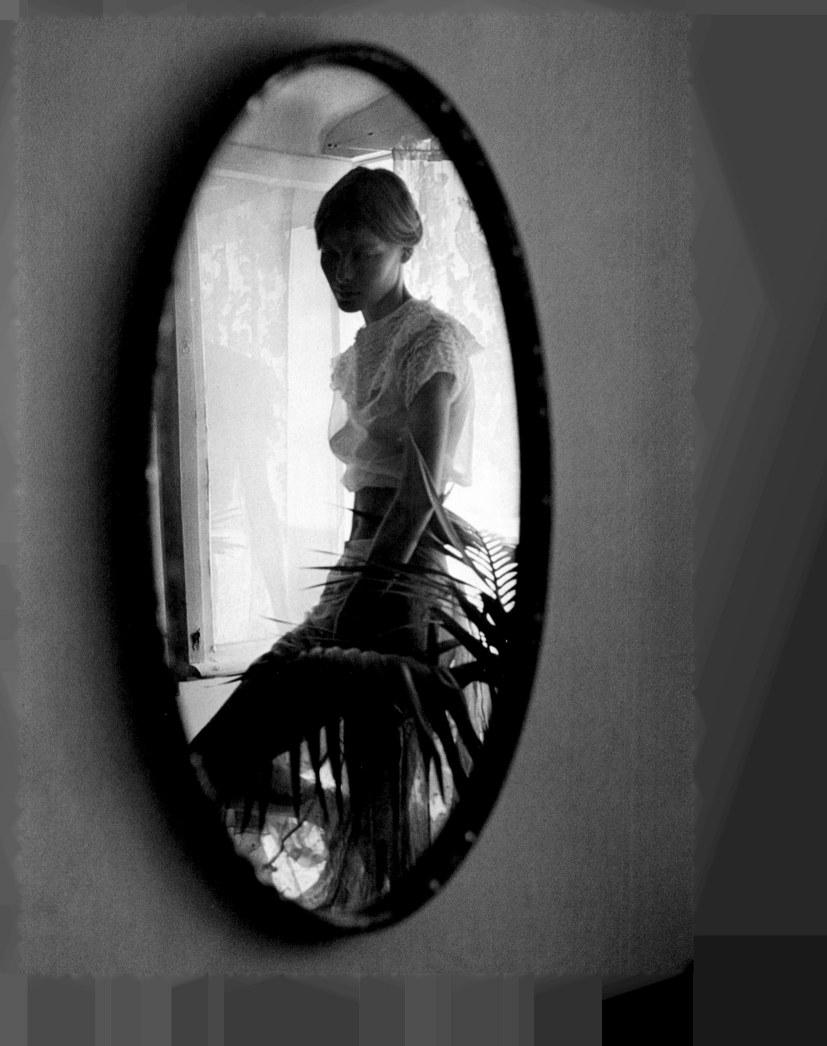

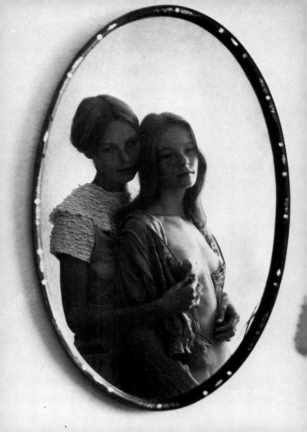

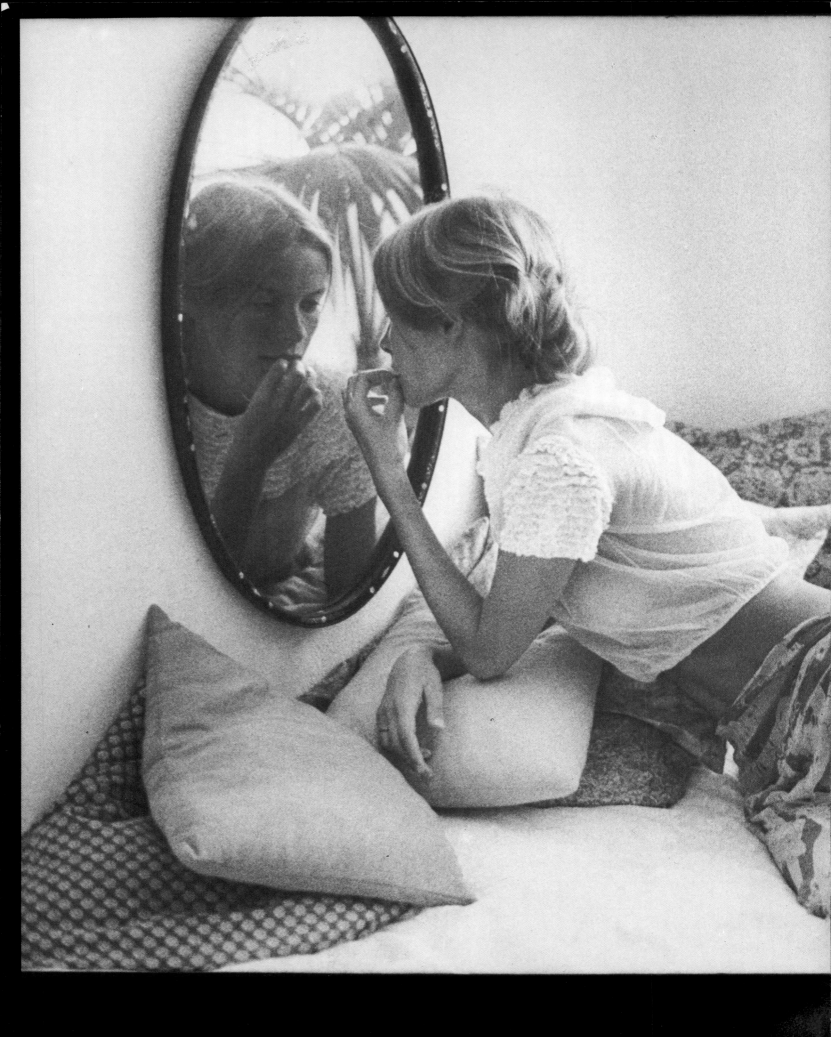

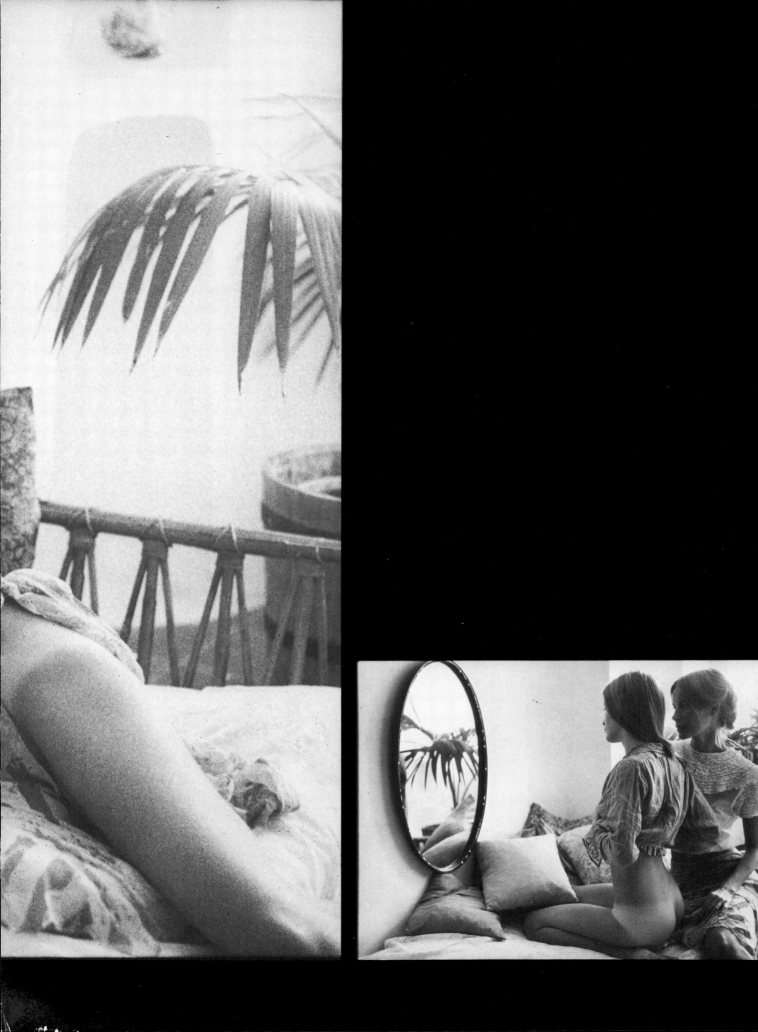

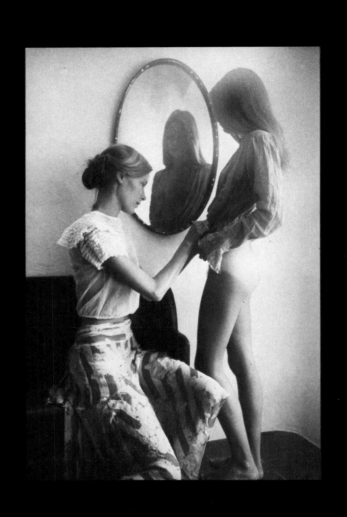

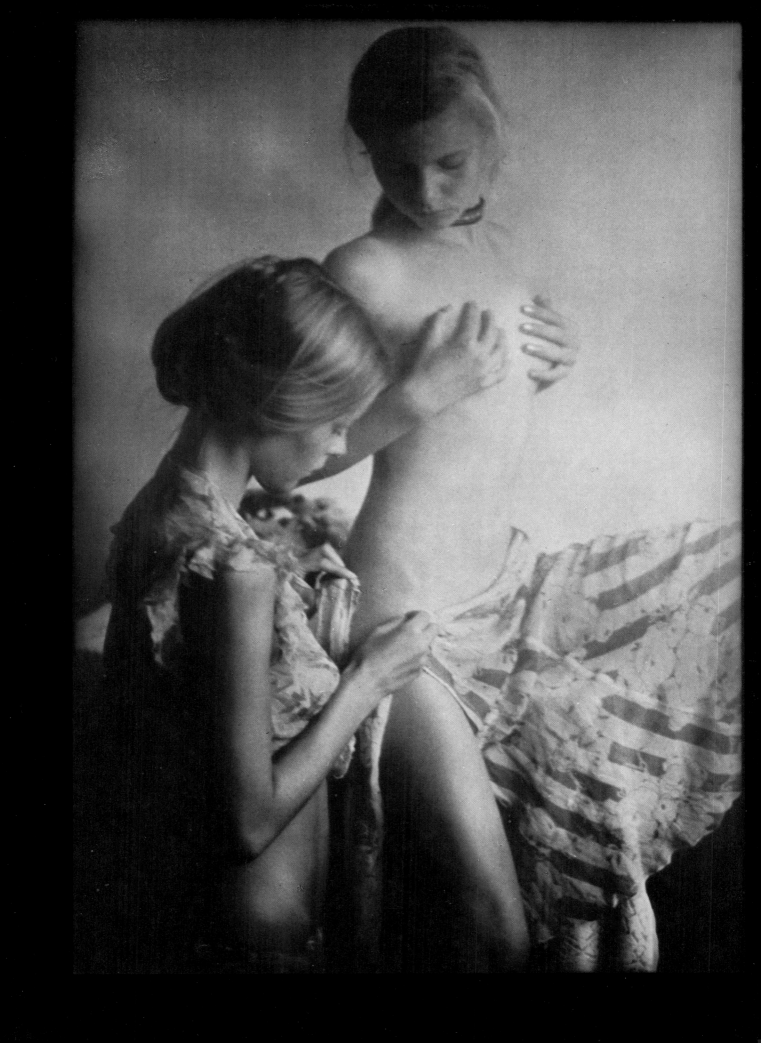

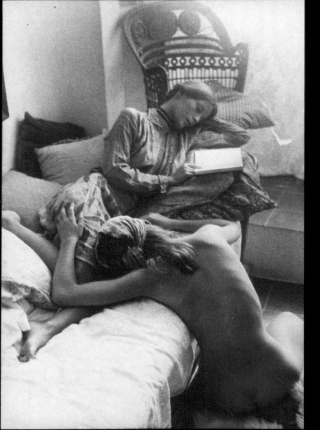
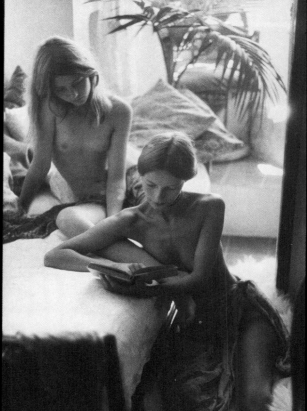

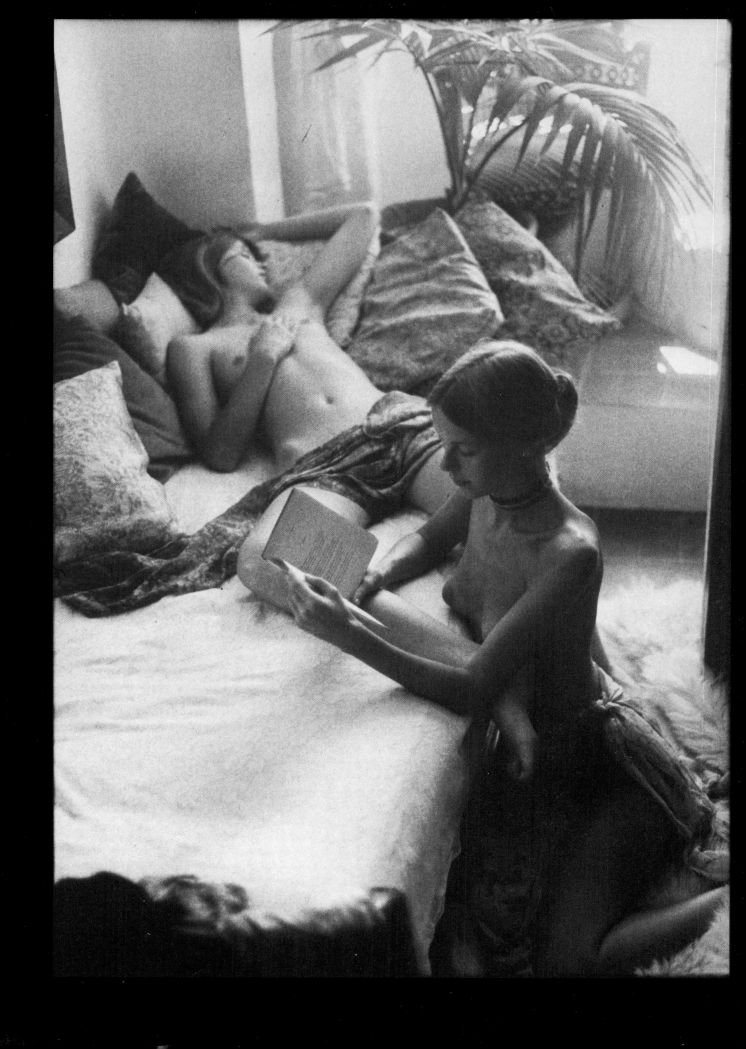

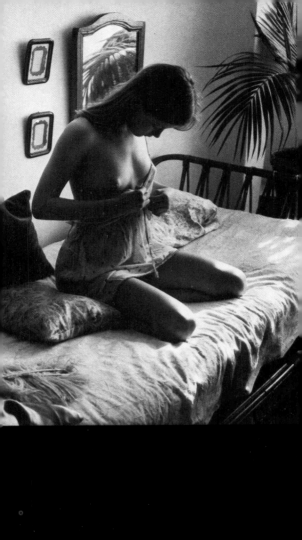

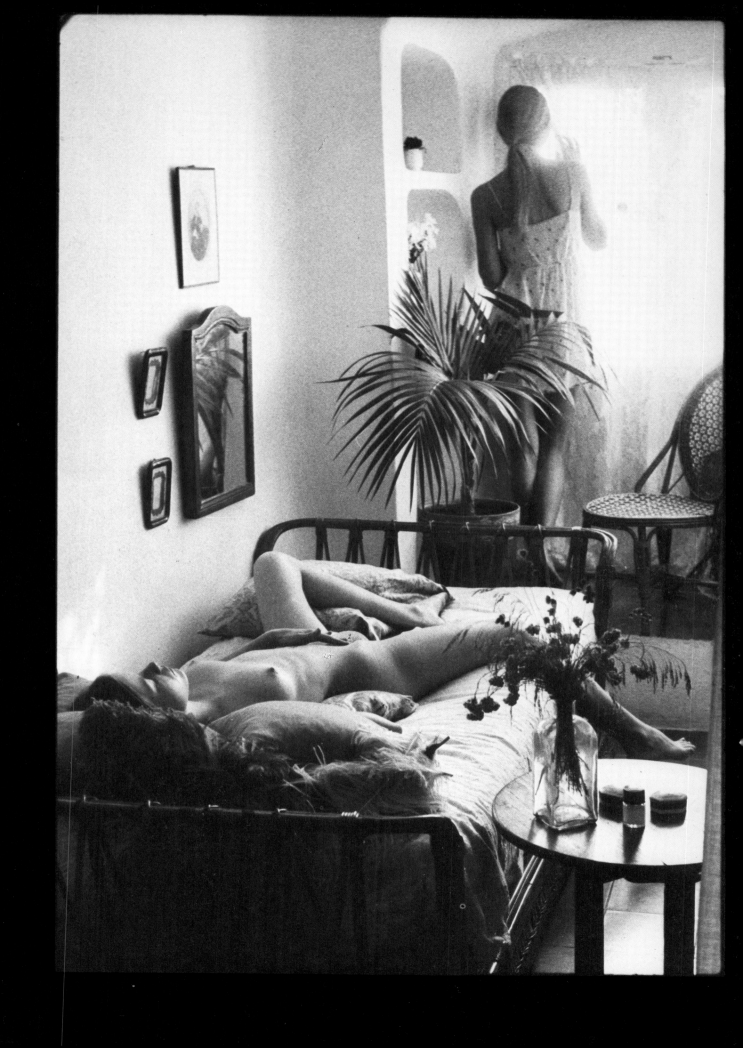

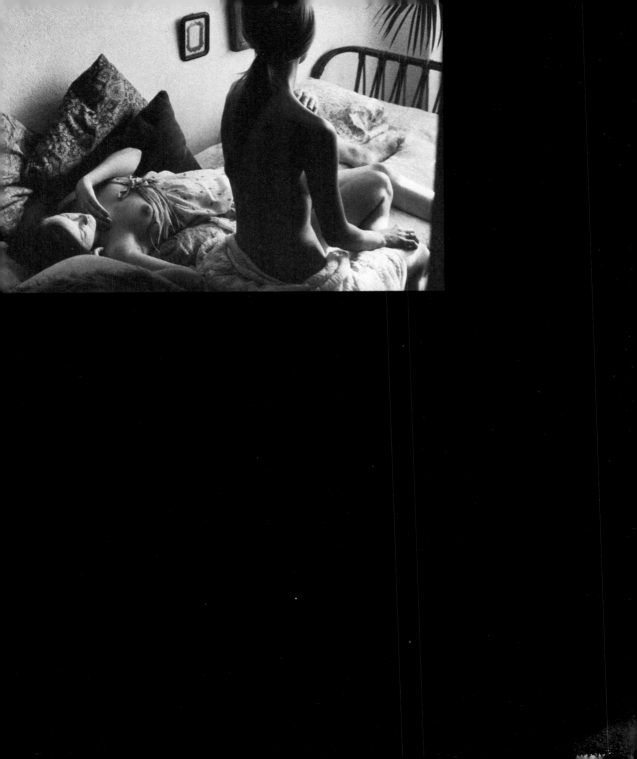

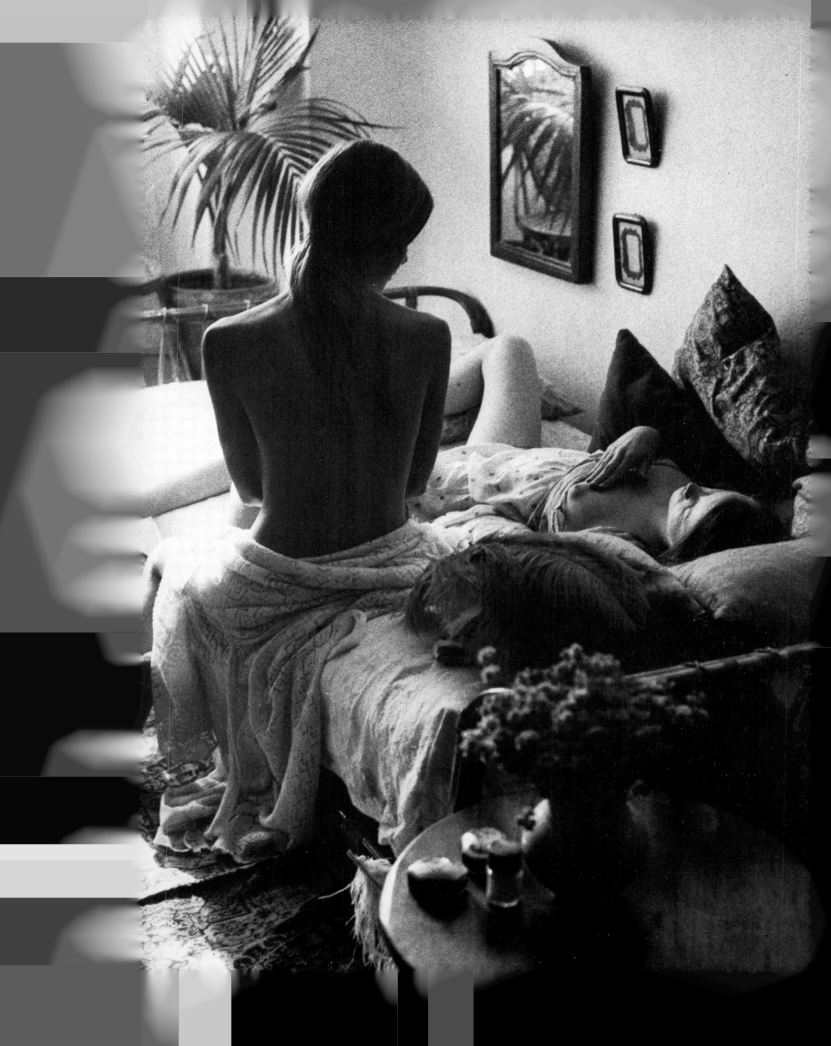

ODORS

The odor of a damp meadow,
as said before, odor of cut hay, of faded flowers,
of leather boots, of empty shells,
the odor of hair, of horses.

You hide in a barn full of hay
where it is much too warm and you dance barefoot
like madwomen, until you are bathed in sweat.

You stop with a start and look out the smallest
of the windows, as if seeing something sensational
down in the little meadow. And you say slowly,
not averting your head:
"The chestnut filly is tinkling, standing with spread
legs."
And after, you draw very close to the other and murmur
in her hair: "You are too warm, little wild horse,
you are wet all over."

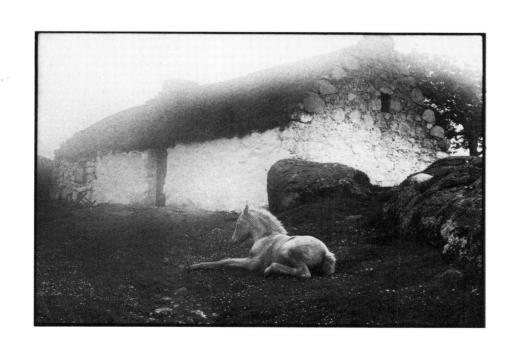

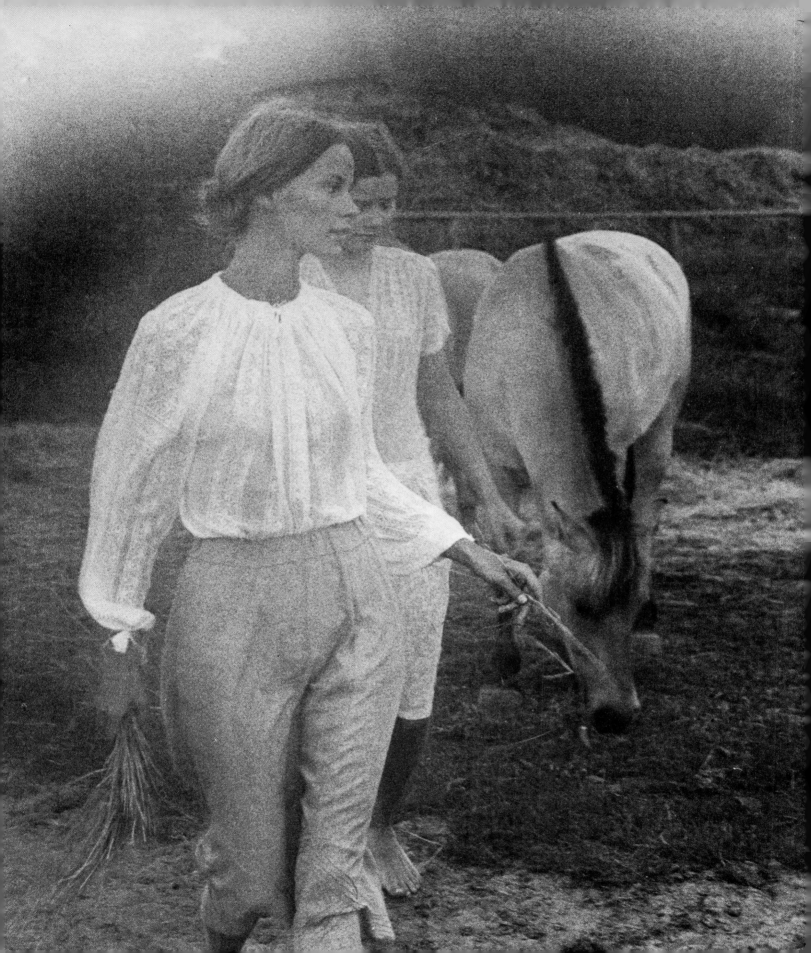

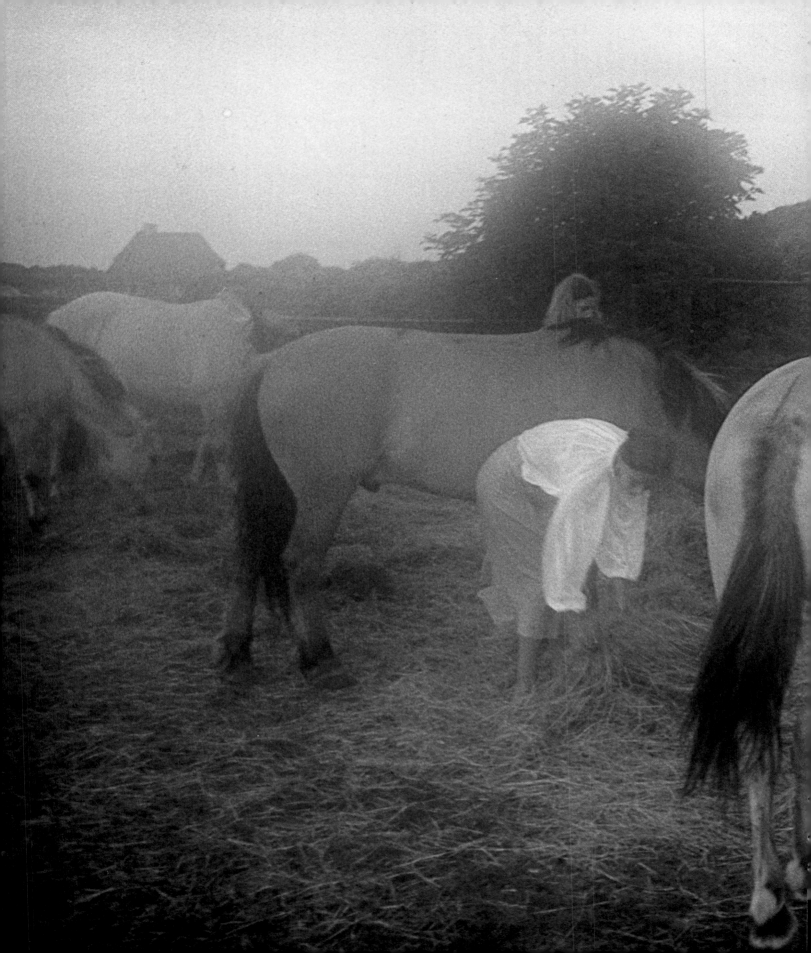

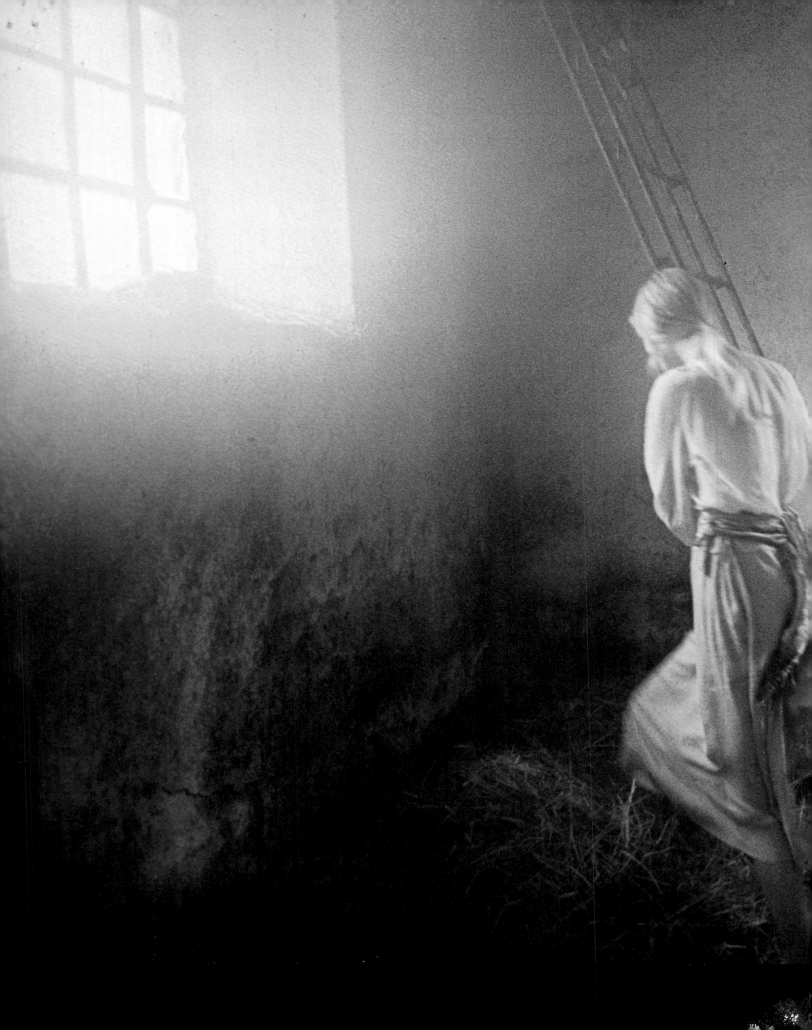

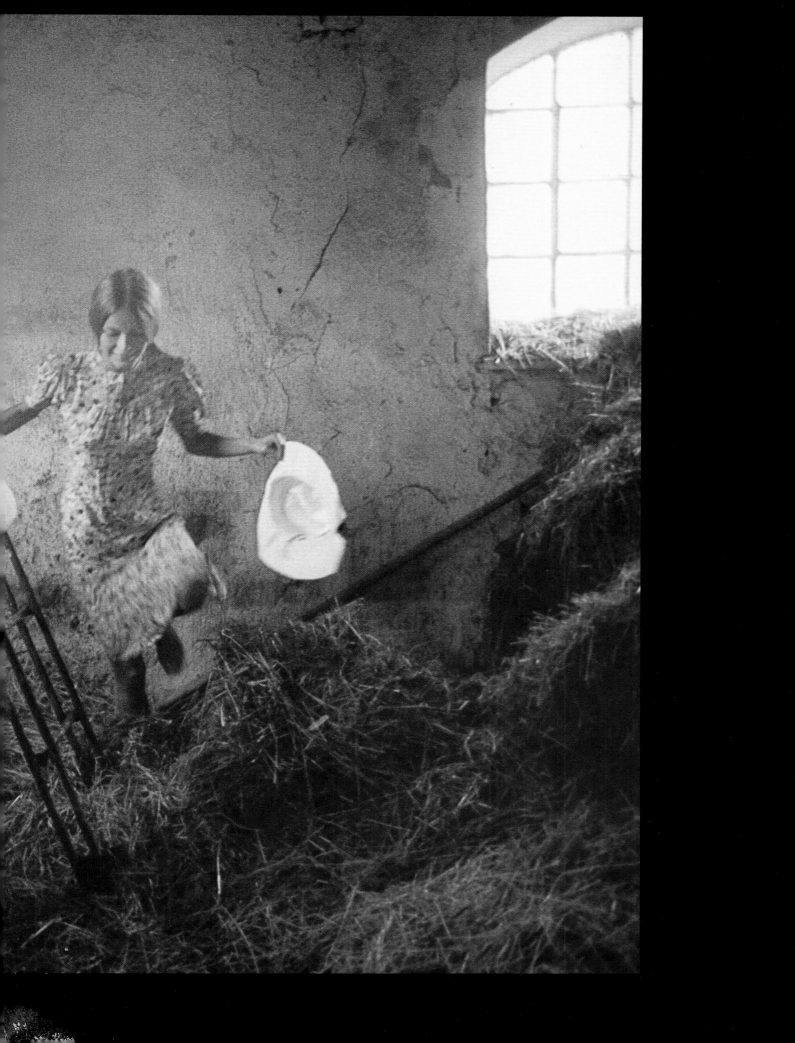

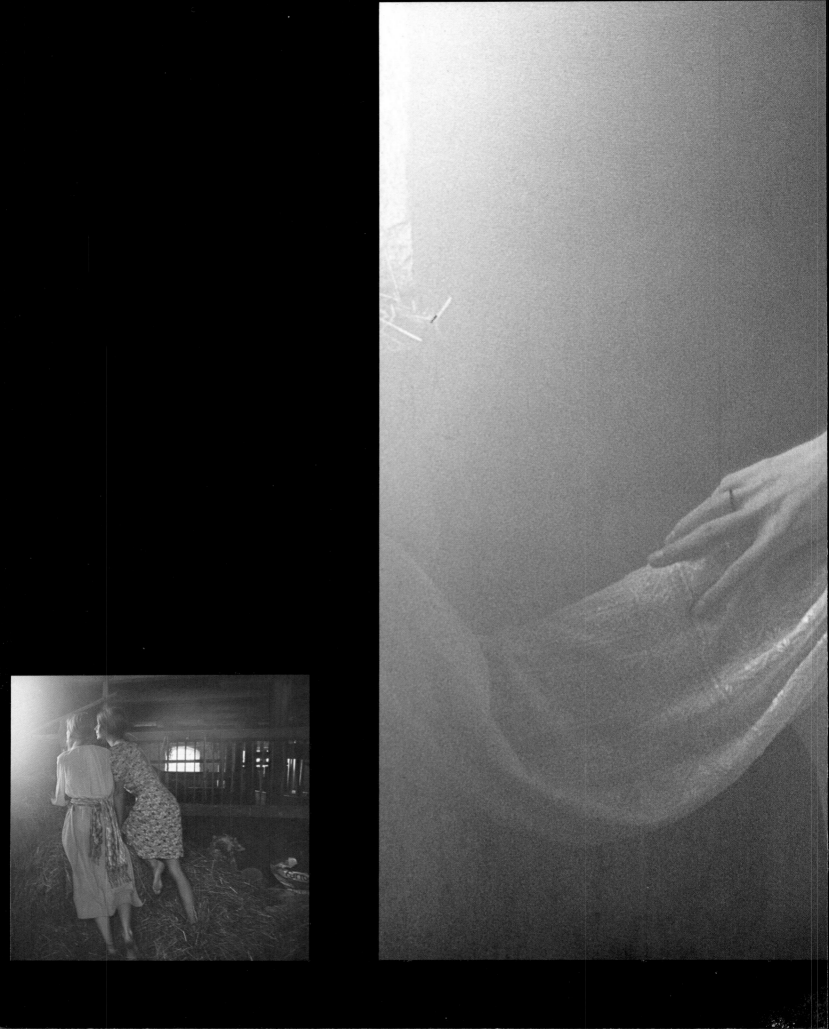

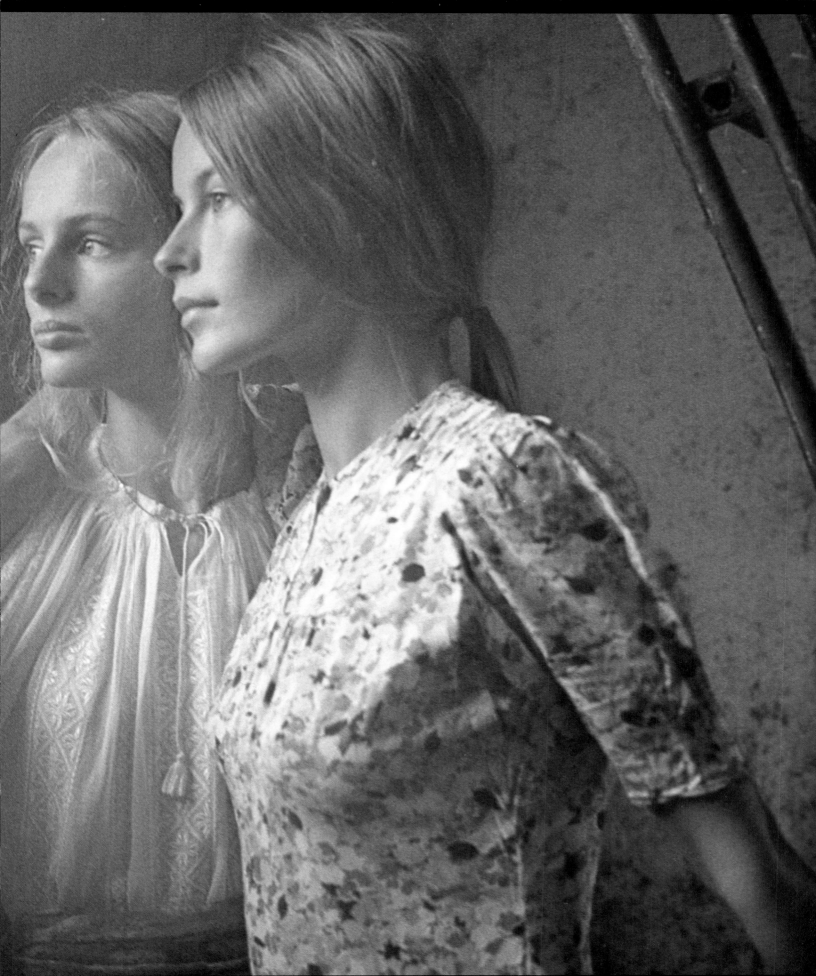

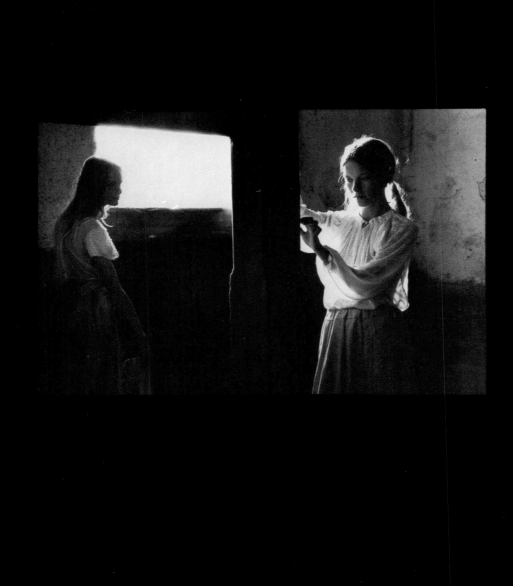

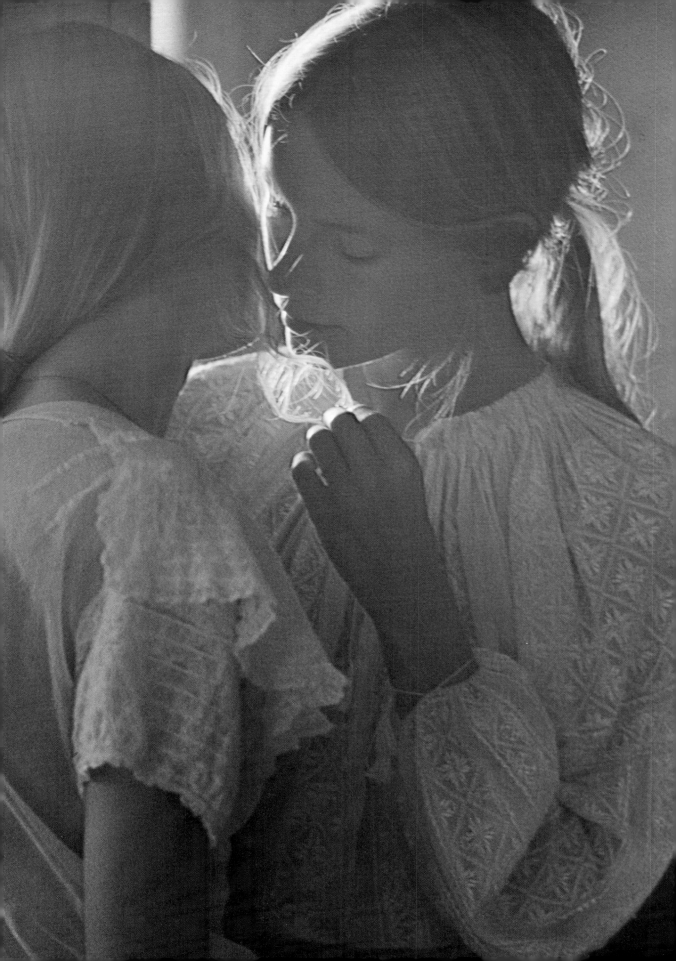

GUSTS OF WIND
BEFORE THE RAIN

With a sudden turn of your head,

appear vexed with her, so that she

must ask your forgiveness.

(She has apparently done nothing wrong – on the contrary.)

And waiting, you turn your back to her

and indifferently brush your hair. She is wily though,

accustomed to sudden changes in the weather; she closes her eyes

waiting for the storm to pass. But you insist she kneel,

and with your hand round her neck you bend her head low,

her face in your lap, helping her to hide her shame.

You say to her: "You are so awkward, you go limp in my arms,

you cling to me like seagrass round a rock." Now, then, is the time

to caress your little prisoner, lightly stroking her sweet shoulders,

bare as if by chance. And then, because she is a fragile thing,

you forgive her and entertain her with a true story:

Once upon a time (or maybe more than once), there was

a little nightdress, a fresh thing of ribbons and fine lace,

which was carried off by a sudden gust of wind one stormy night.

The wind lifted it out the window and let it drop finally

beneath a thorny bush where it lay a prisoner,

unable to move, being held at the neck and arms by spiny branches.

When an hour had passed, the little thing was nothing but tatters,

as the wind had grappled with it wildly, tearing it to shreds.

Then came the lightning and it struck mightily, as if to deliver

the nightdress. The thicket burst into flames with the splendor

of a bonfire on a fall night. Soon after, the rain came and fell

in torrents. When the little nightdress returned home the next

morning, she was a sorry sight indeed,

good for the rag pile, if even that.

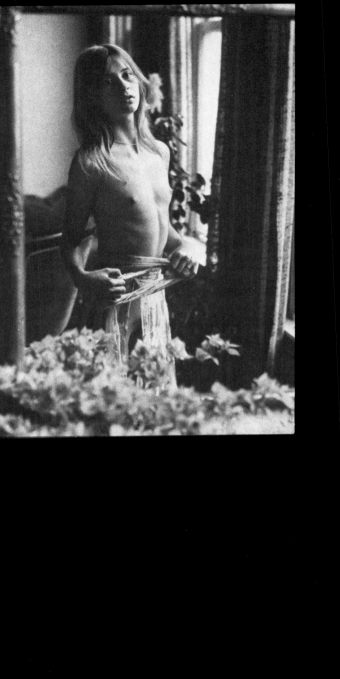

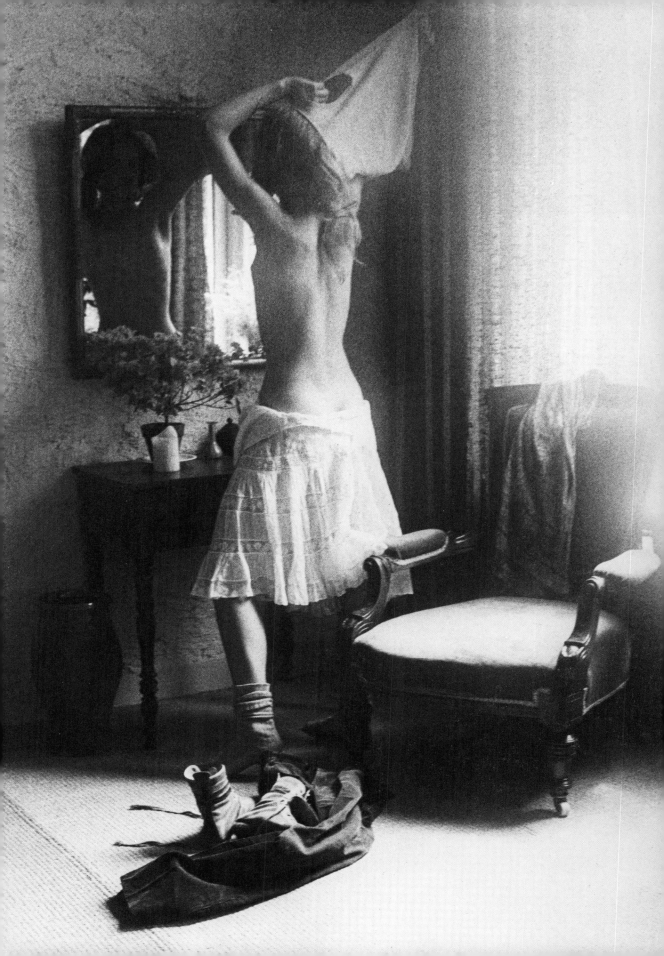

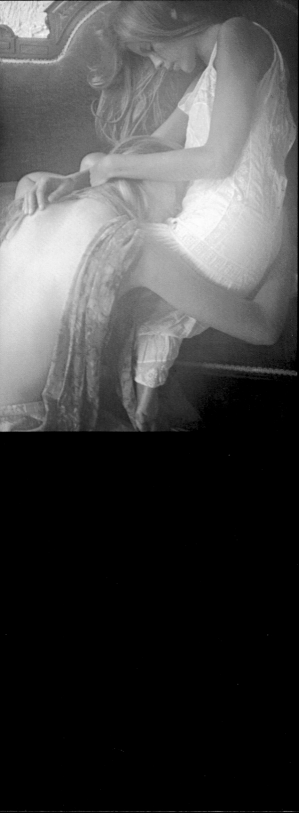

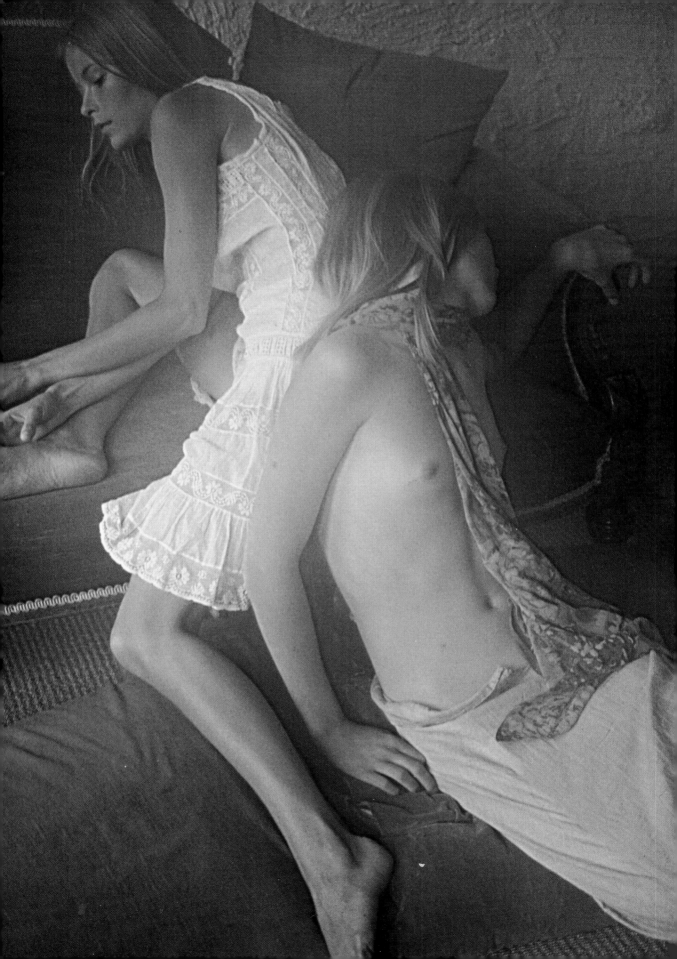

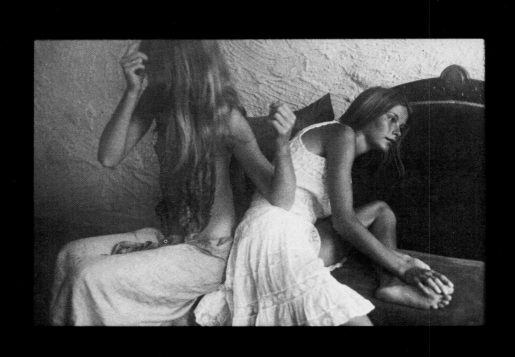

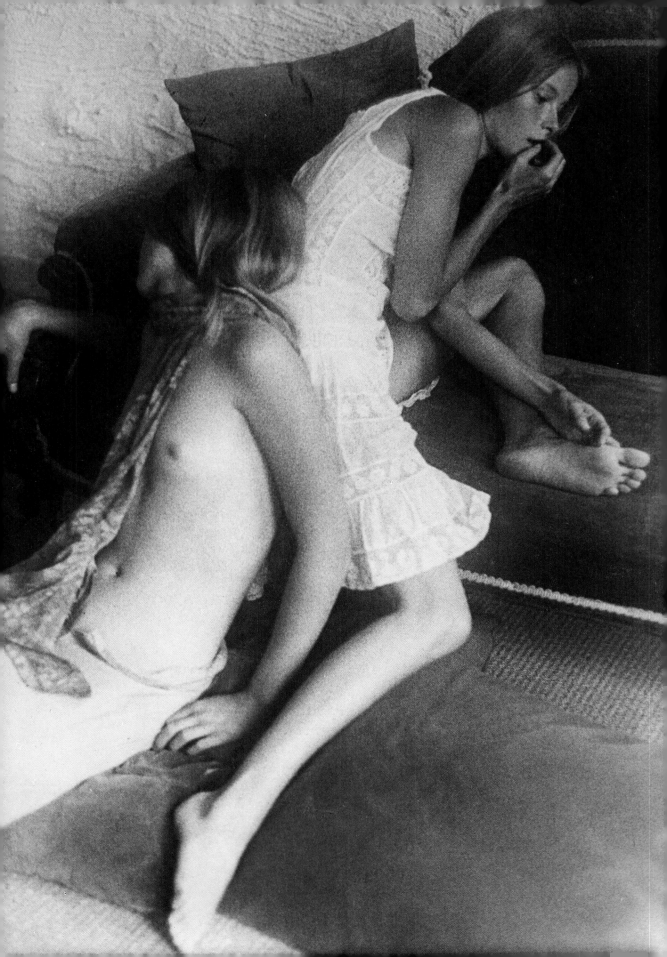

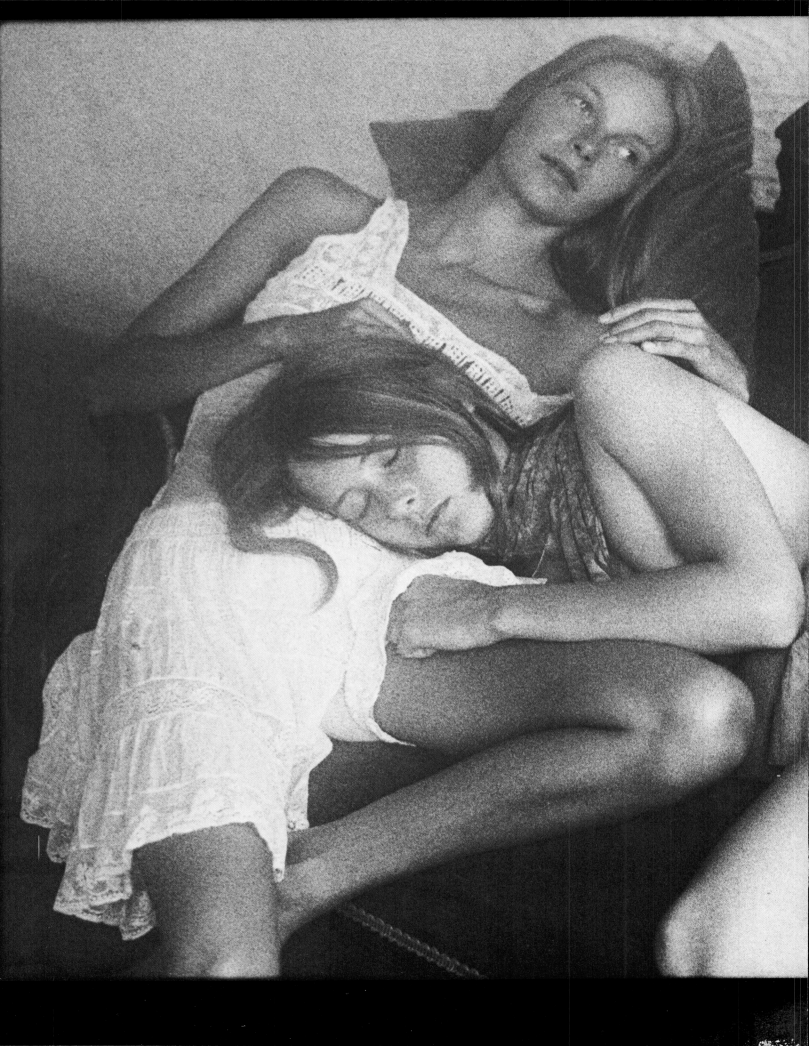

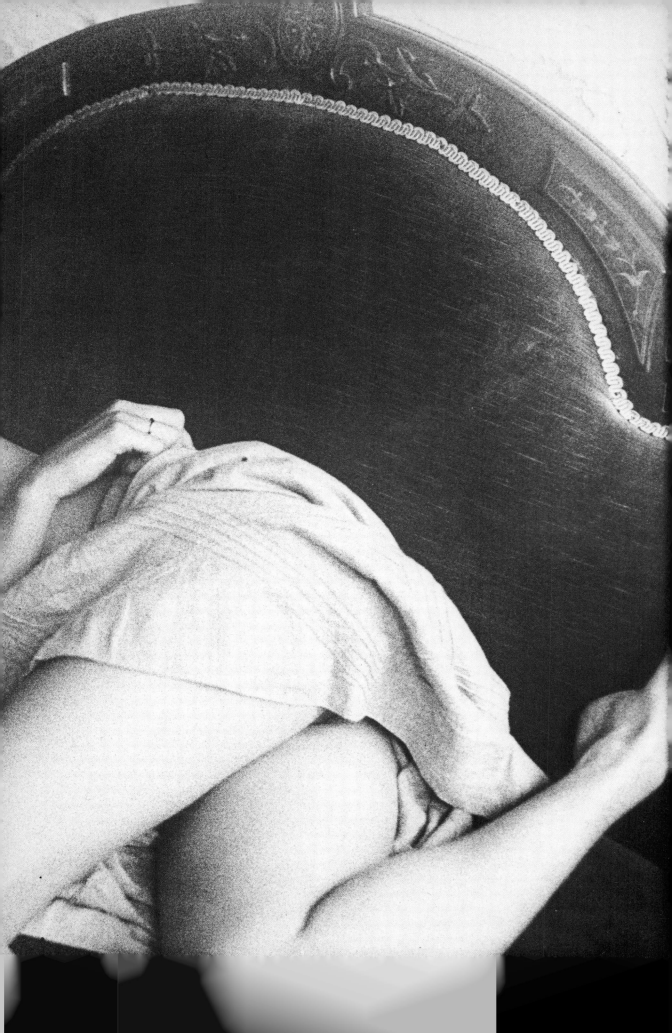

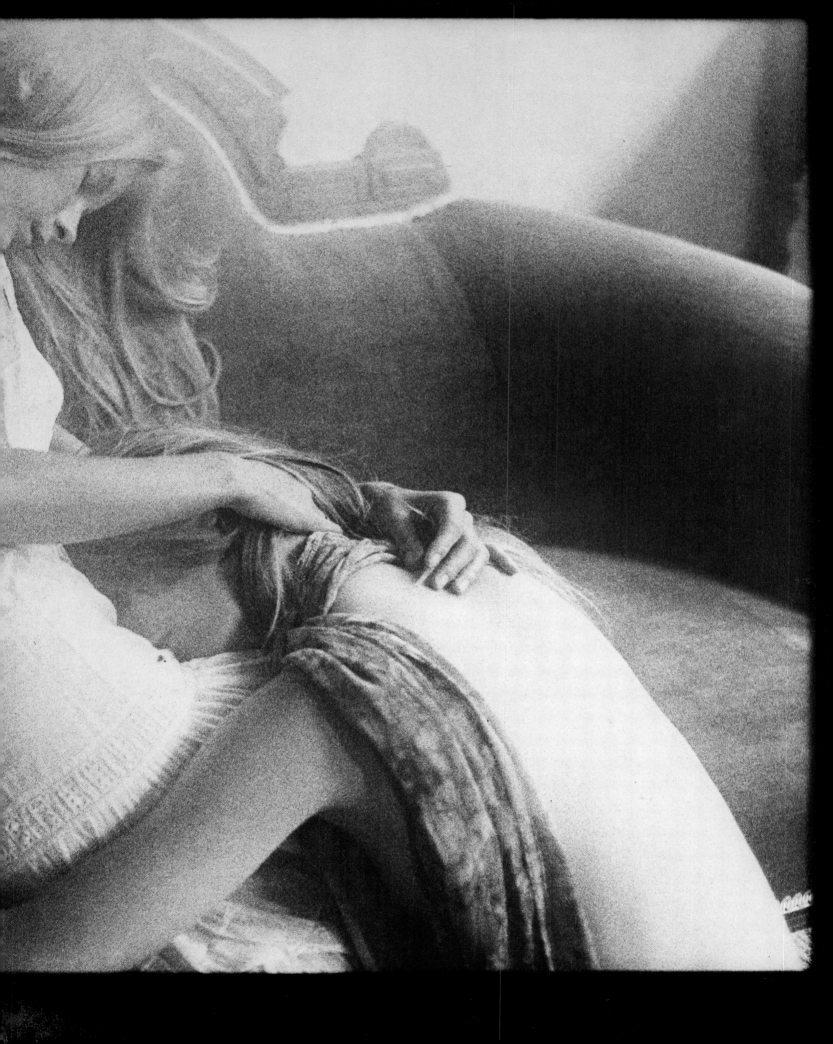

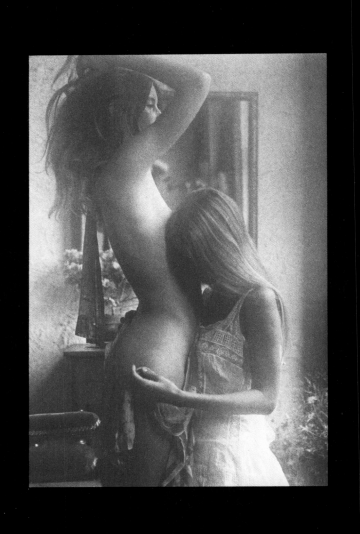

AN OUTING

You have grown silent.
There is nothing left to say to each other. Your heads
 are void of ideas, your ears filled with a chorus of insects
buzzing at you from all sides. You are out
 in the country, sometime before the other war, or toward the end
 of the last century. But on this outing
 there are no parents and no boys along.
 You carry umbrellas pretending they are parasols, and wicker picnic baskets.
You read old-fashioned novels set in the depths
 of darkest Africa, full of psychological dramas,
 incomprehensible in the clammy heat and chirring of crickets.
 Beneath the huge tree the coffee pot is still on the table,
 beside the breakfast cups which you have not yet
 cleared away.
You have stolen the voyeur's bicycle. It is a terribly old thing,
 a man's bicycle abandoned long ago in the sheep pen
 (you have seen it lying there for years). You call
 it that because of a horrid story you made up about it . . .
The bicycle is better than yours because the crossbar
 holds up your skirts in front, leaving your thighs free.

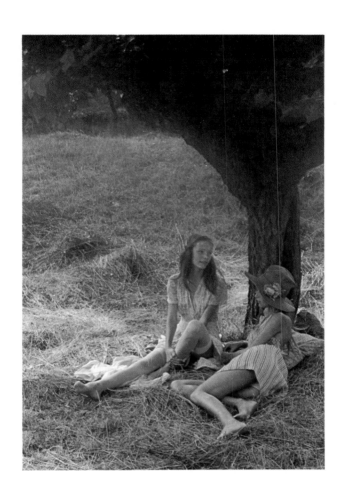

You have overloaded the handlebars and rack with wildflowers
you have gathered. You are bored. You make bouquets
which wilt so soon. You are always together.
 Time no longer exists. For days and days
you have not spoken to one another. I almost think
 you have forgotten how. And then, suddenly,
 you might hear a bizarre sound,
 like a knife on a grindstone, which comes from around the curve.
 You might look at each other, still
saying nothing. And then flee with a single movement,
 abandoning bicycles, parasols, picnic basket,
 leaping into the brush.
 You might be terribly frightened.
And then, as usual, there will be a dizzy stairway
 and a long corridor, where blood runs out from under the door
 of a room which is always locked. It is once more
 the same horrid tale which begins in your dream
 in the shadow of a huge immobile tree.

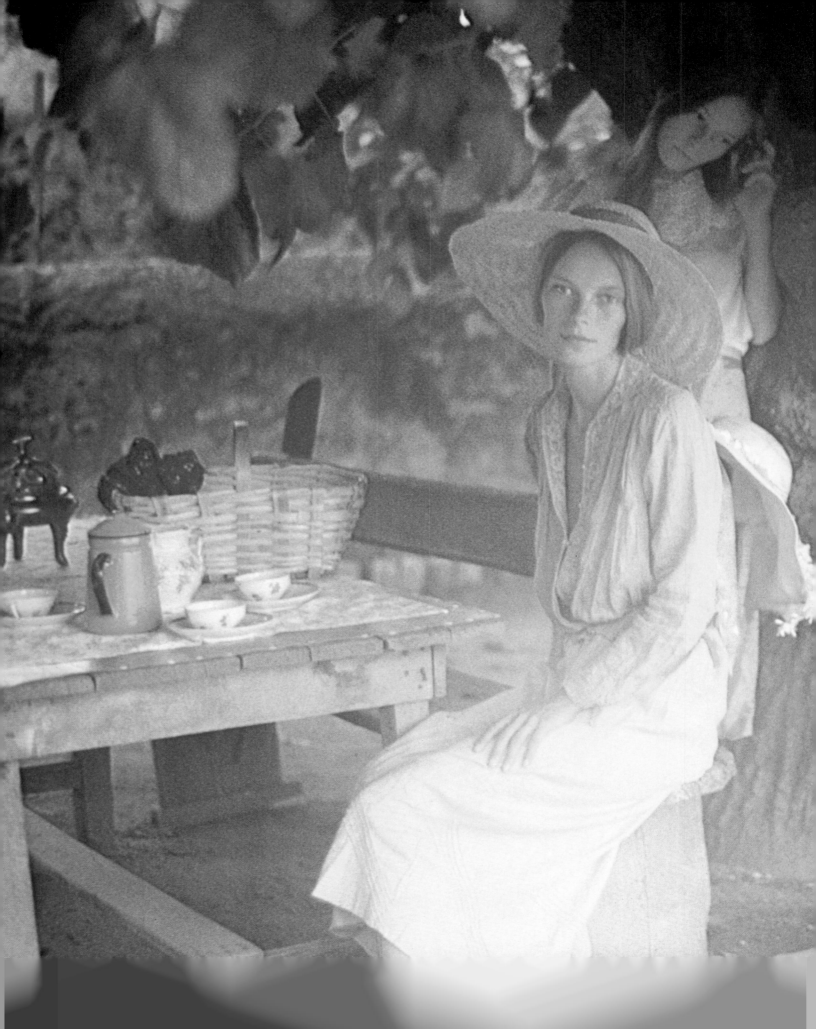

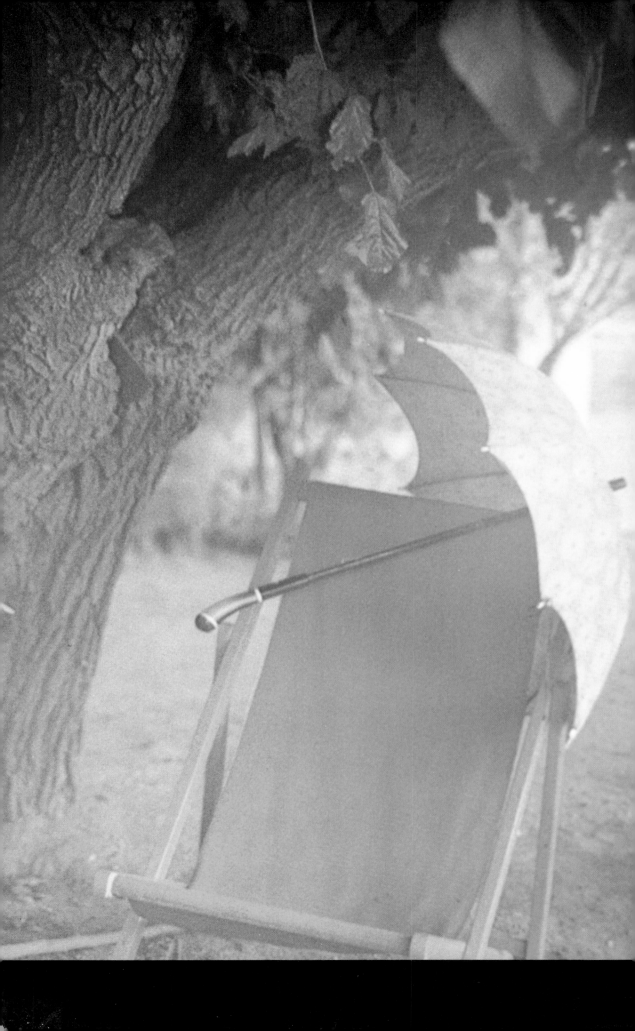

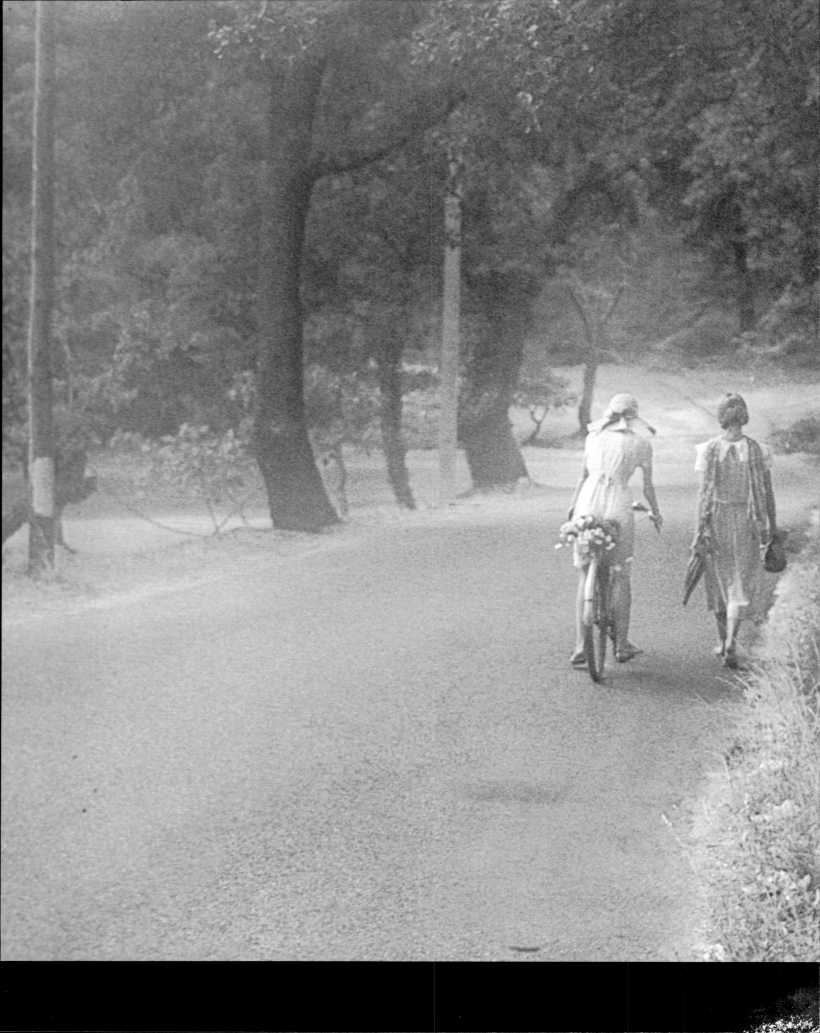

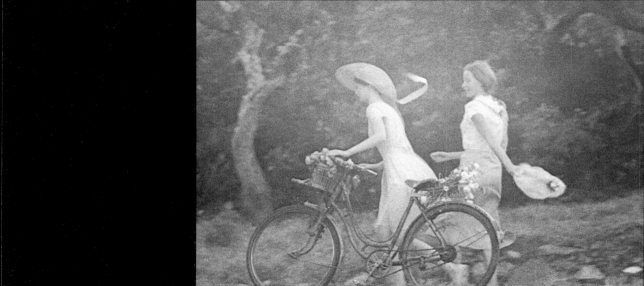

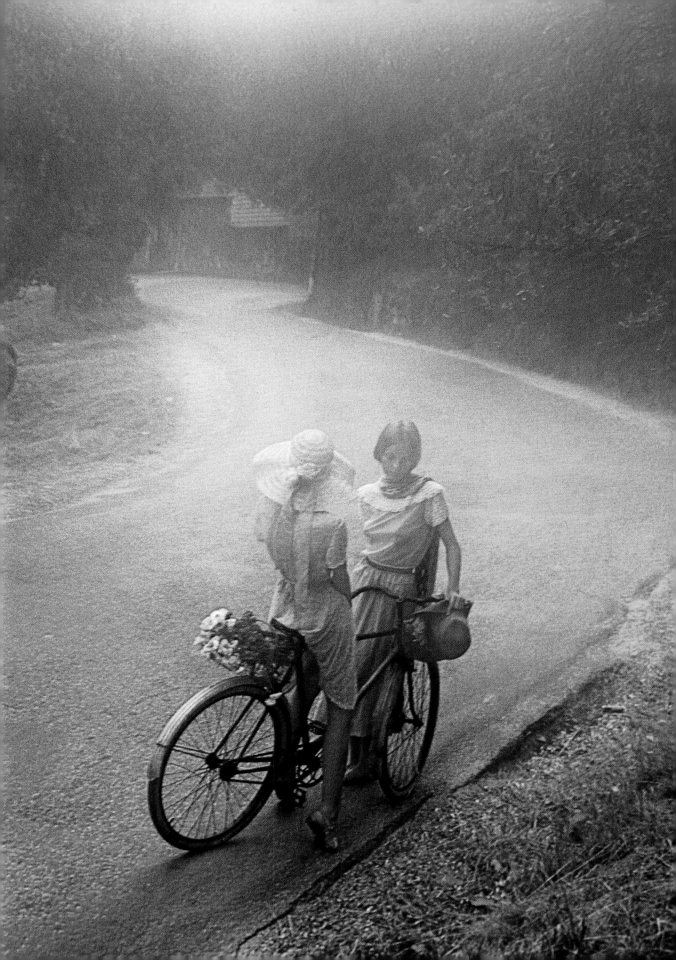

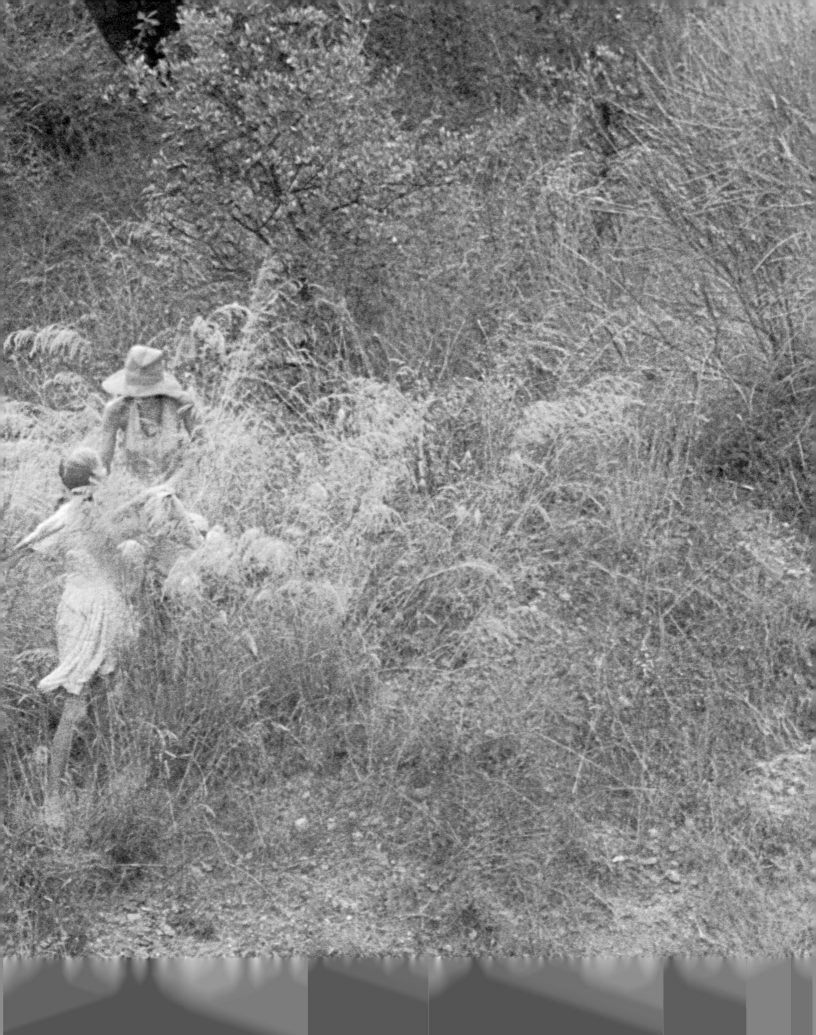

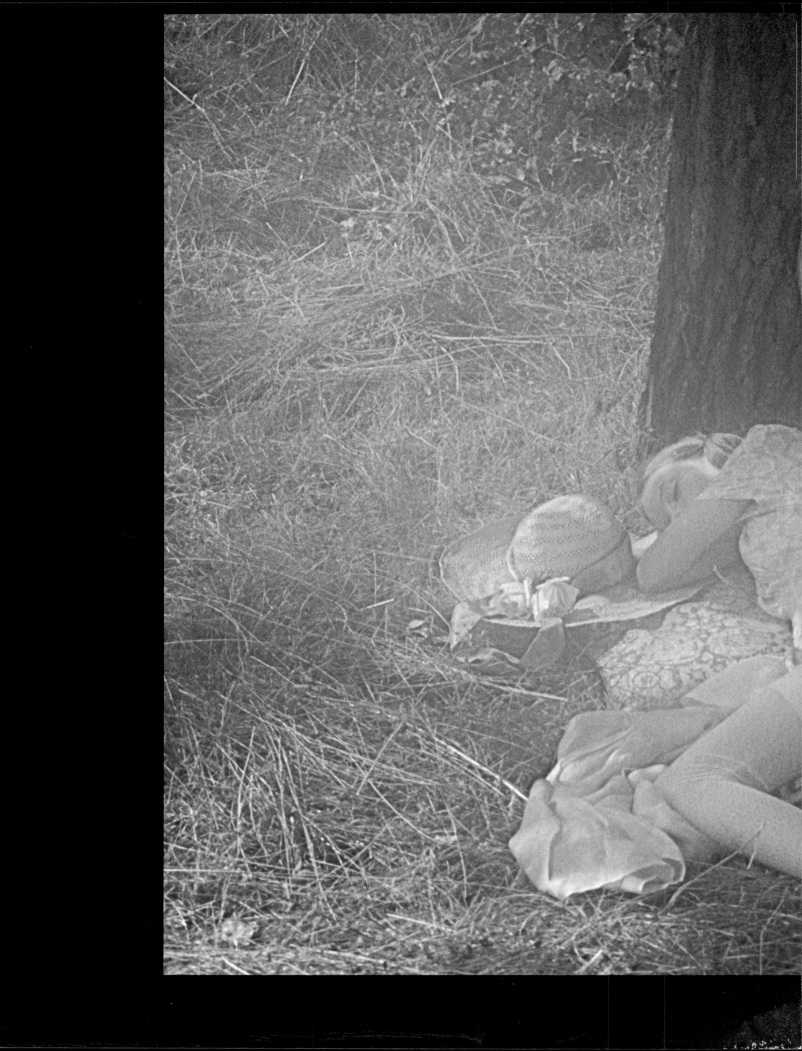

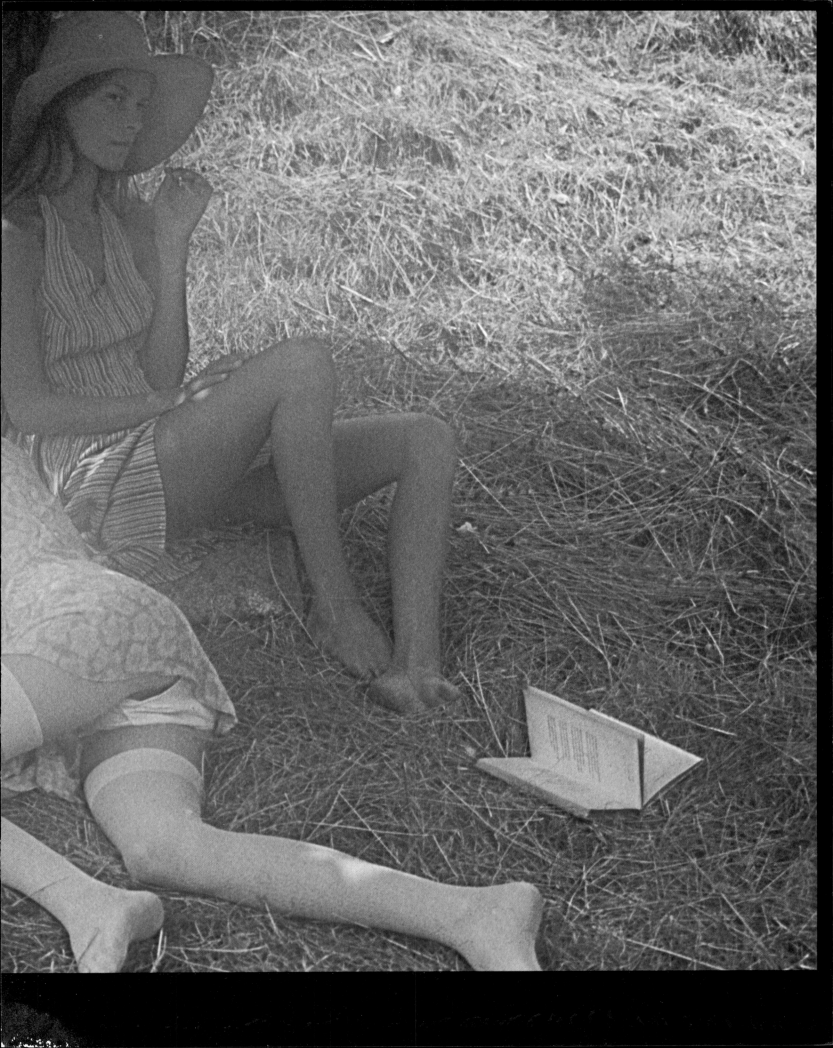

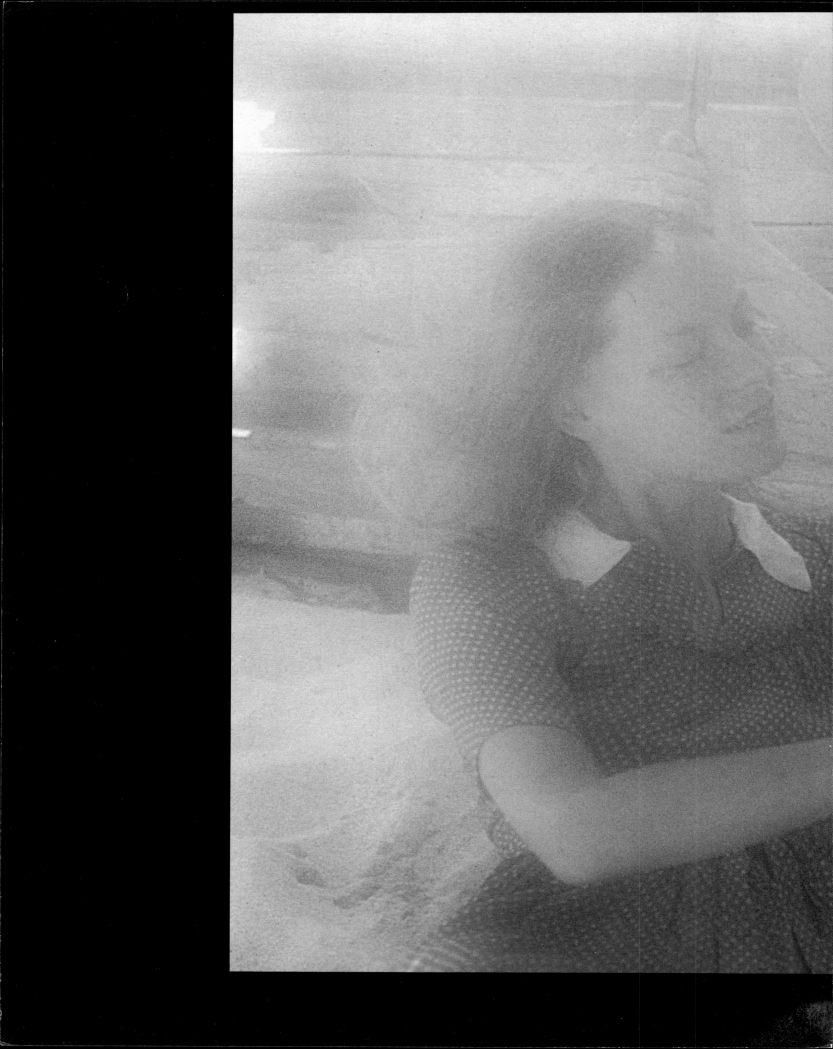

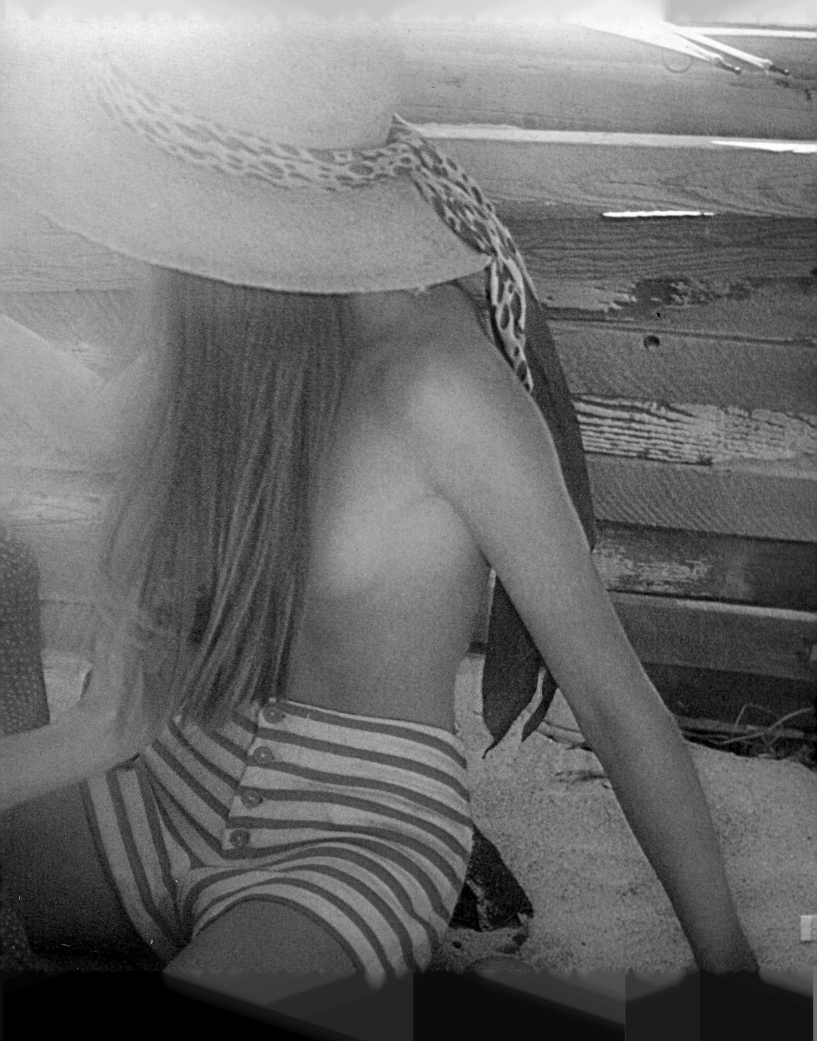

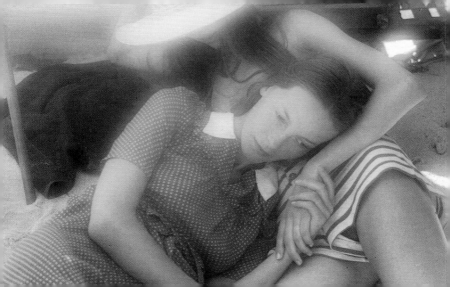

SOMNOLENT DEMON

She has cried out in her sleep.
It is like a howl of terror which never clears
 her throat, where it dies into something of a rejected rattle,
long and plaintive, rising or falling with greater or lesser volume,
 at the mercy of some wave, rolling up out of fiery depths.
 Taking her hand isn't enough to calm her
 terror of being sucked down into this flooded underworld.
 The seventh surge, more violent still, exacts a
 painful moan from her. You need to treat her more roughly, seize
her by the shoulders, bring her to her feet,
 slap her, shake her like a rag doll.
The torn bits of her nightmare drop off, one by one,
 and fall about her feet, like so many odd trinkets.
 Now finally half awake, she catches a glimpse of herself in the
 rectangular mirror over the divan where she lay in a drowse.
She is nude, she scarcely recognizes herself. And once again she is
 absorbed in a dream, lying on her back in the grass, exposed, inviting,
 her legs parted and her hands clasped
 behind her neck, among the cushions beneath the great immobile
 mirror, maleficent no doubt, a prisoner of her phantom selves,
 asleep in her own arms.
 To be able to disentangle her from the nightmarish caresses
 which still pull here and there at her young flesh,
 to efface the dust from the road, the pearls of dew,
 the bits of brush or faded flowers caught in her secret
 shock of hair, you now need to wash her body with spring water,
fetched when the sun is high. One cannot trust that from the well;
 too deeply dug, perhaps. She whimpers a bit
 under the long streams which wash over her so thoroughly.
 Is she again spotless, innocent, purified for the sacrifice?
You check her over with meticulous care, even into her guilty folds
 for any suspicious marks the demon may have left on her.
 She lets you. She says nothing more. She is not there.
She will soon drop off to sleep again.

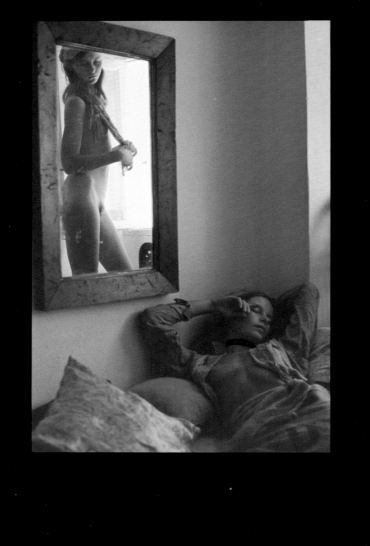

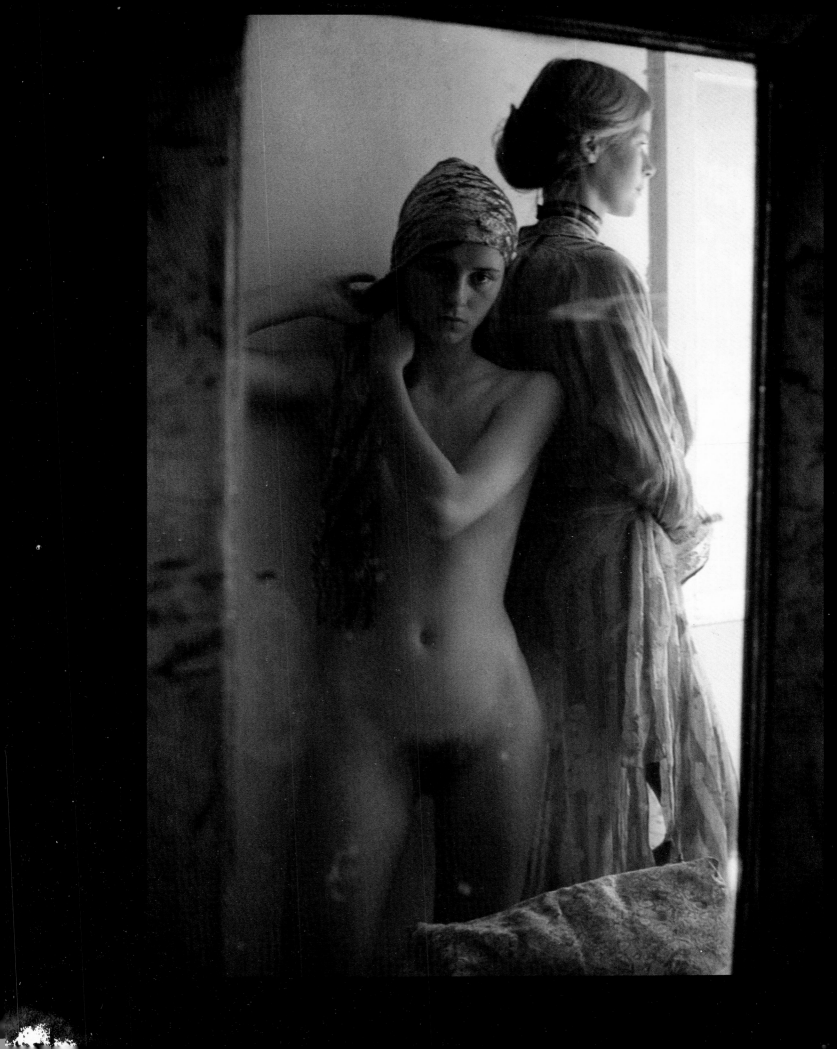

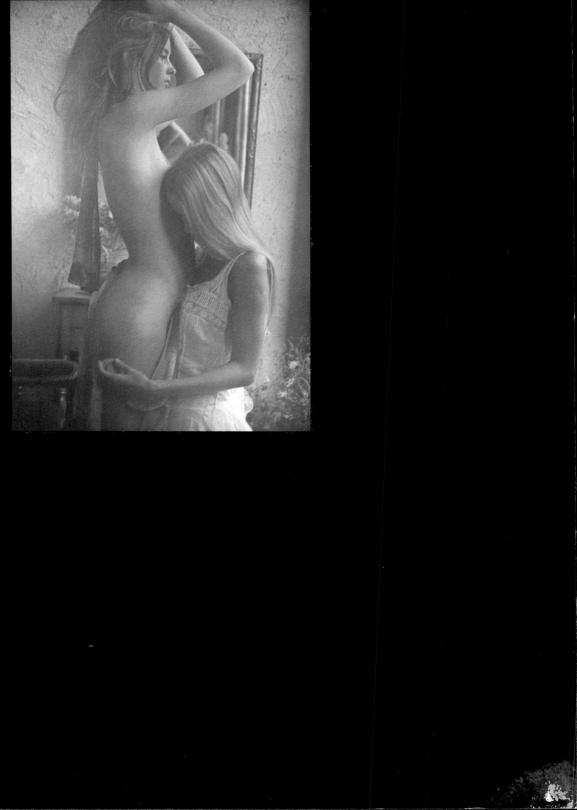

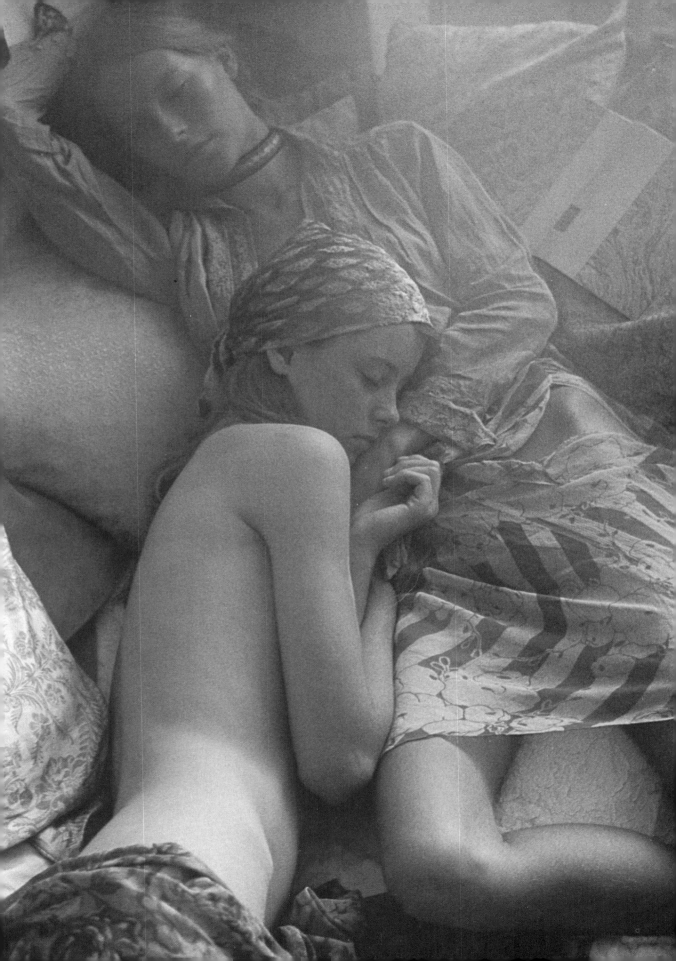

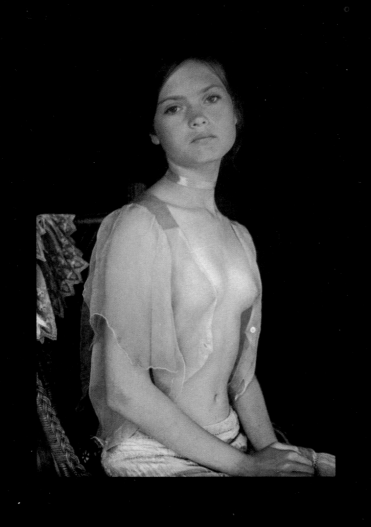

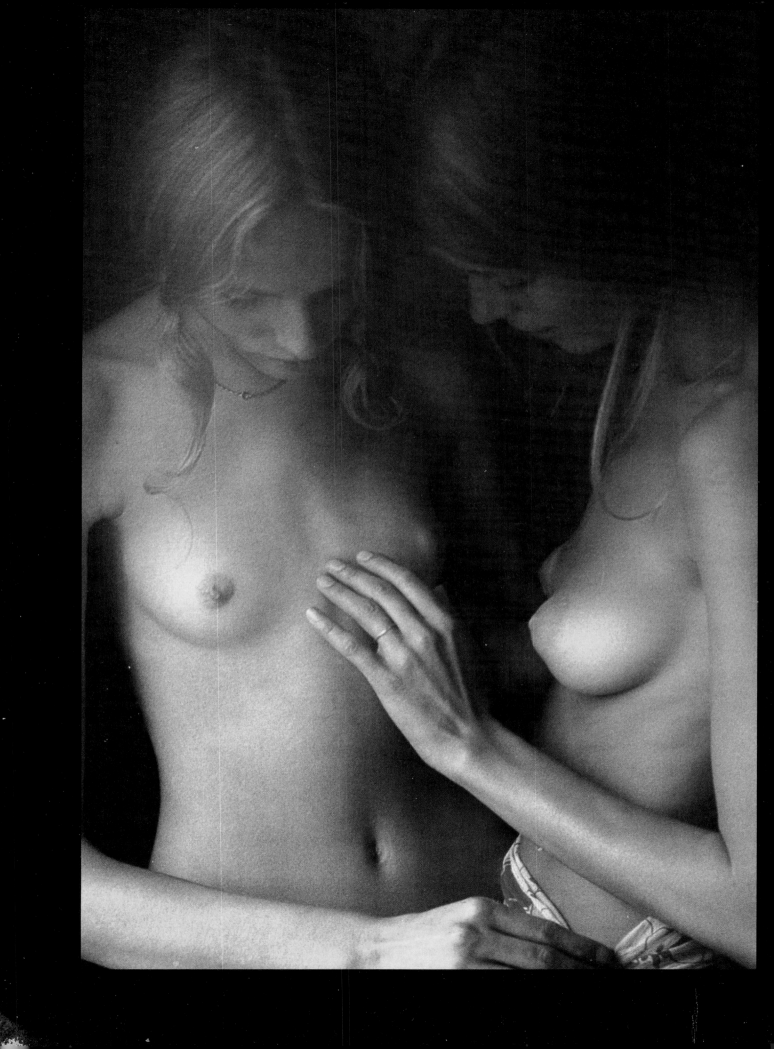

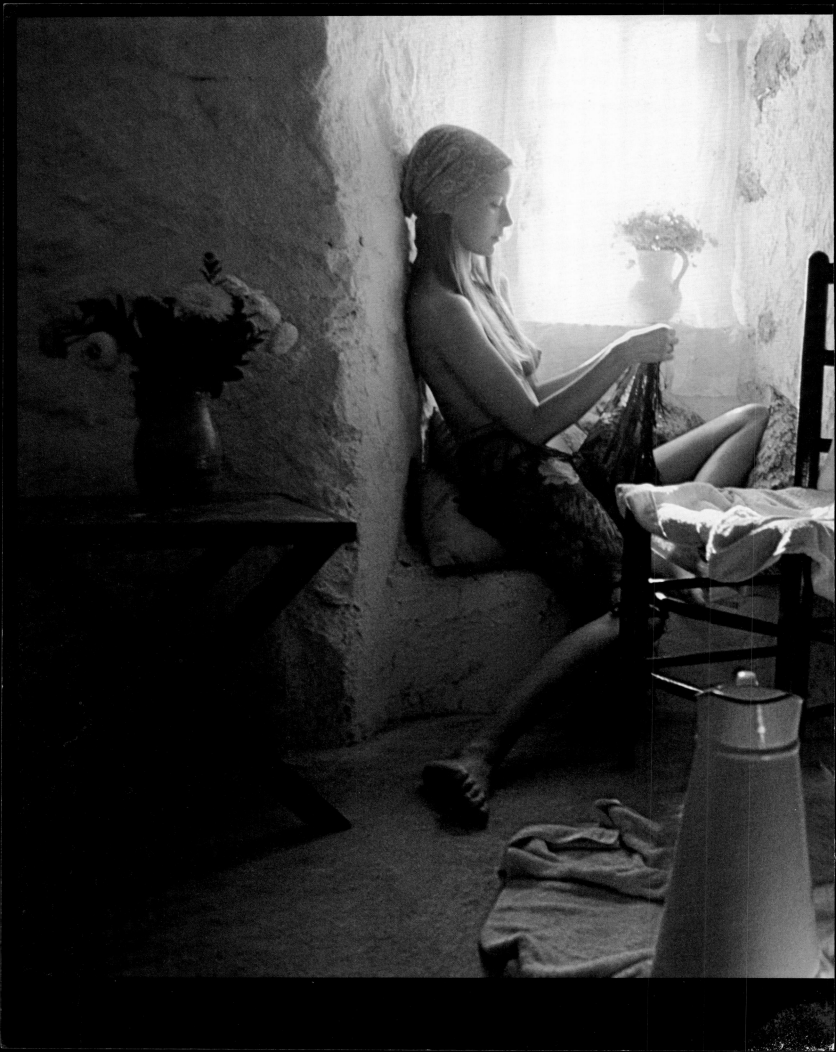

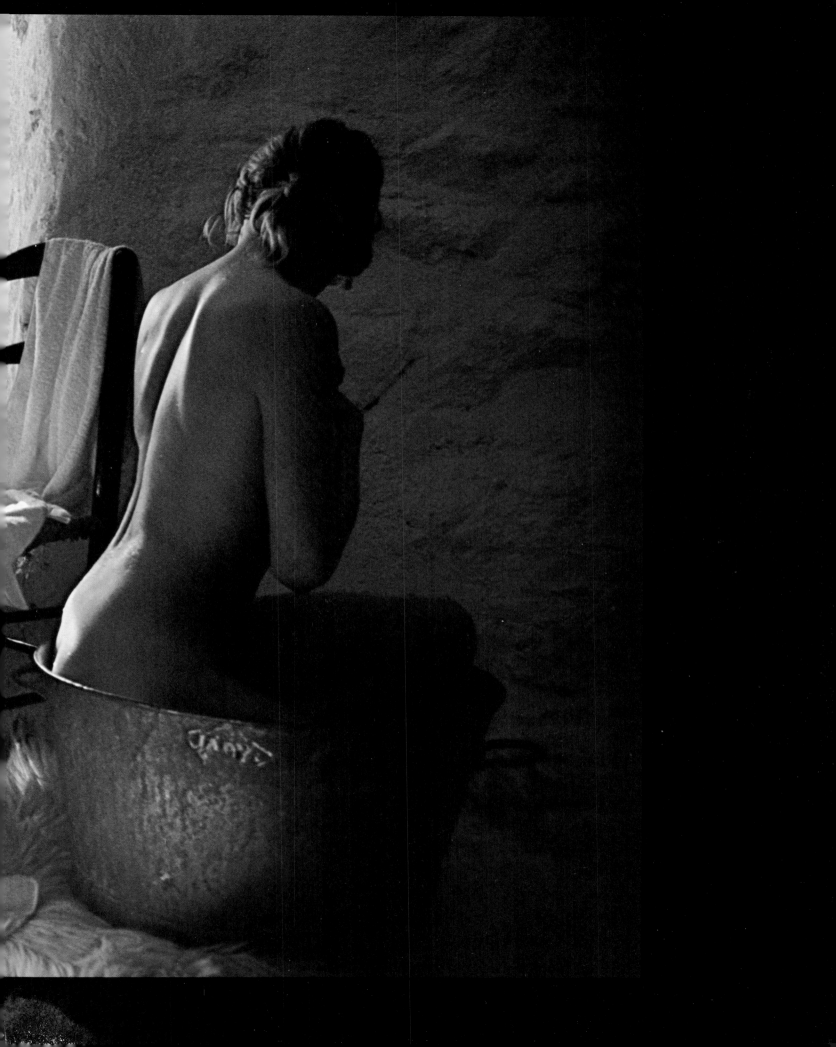

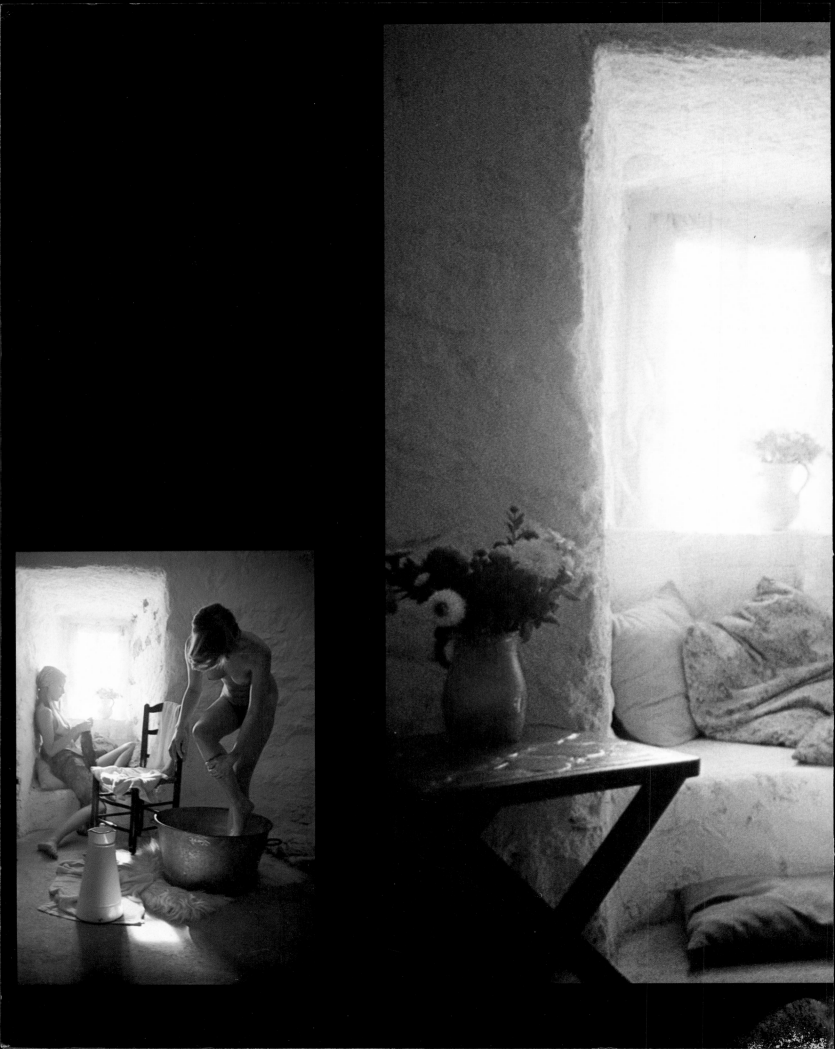

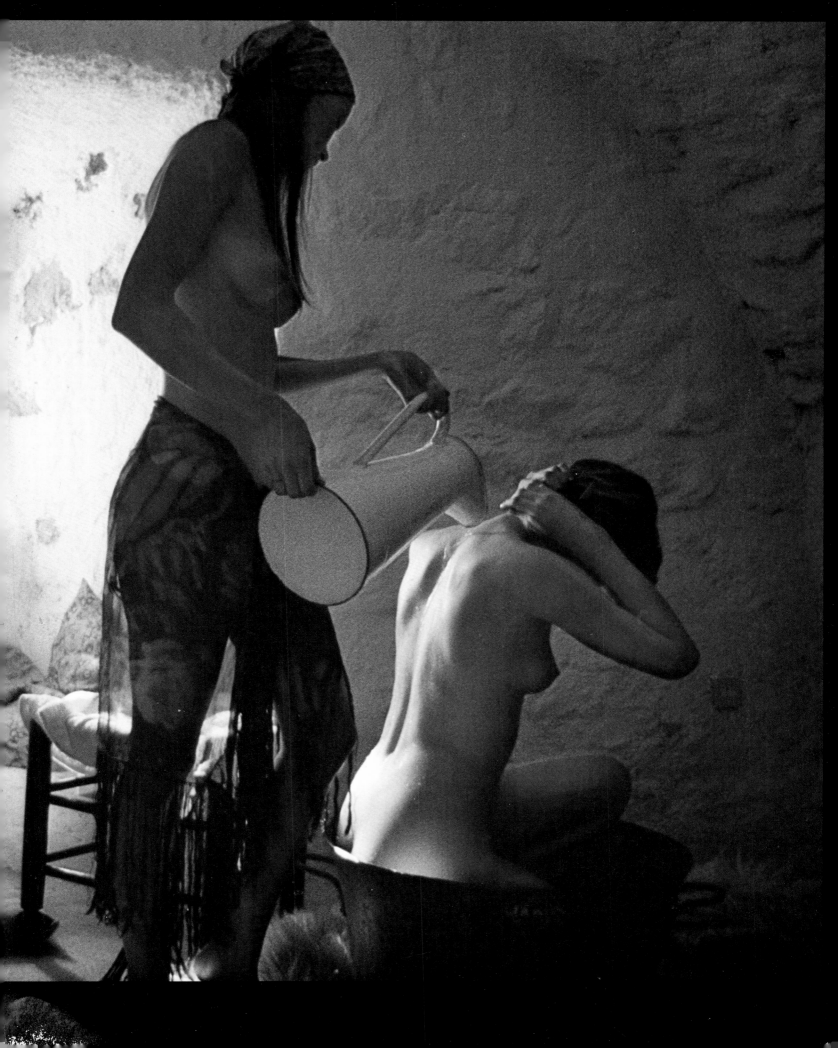

METAMORPHOSIS AND ASSUMPTION

Look – she has once more
transformed herself into a dove: you have hardly turned your back
when great white feathers sprout forth and fan out
in the sunlight . . . This is becoming quite annoying!
But you are certain you have removed the creature's mark
on her left breast, on the very edge of the areola;
and yet again she pretends to be an angel. There she is
taking flight, beating the air freely
with her heavy sumptuous wings, making a fiendish noise.

And the two of you stand there, watching her fade into the distance
over the dry stone wall, towards the end of the meadow
where she is nothing but a slender cloud of russet vapor,
there at the edge of the impenetrable forest.

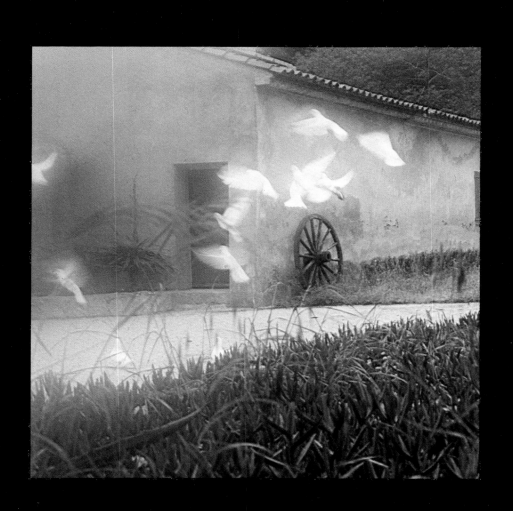

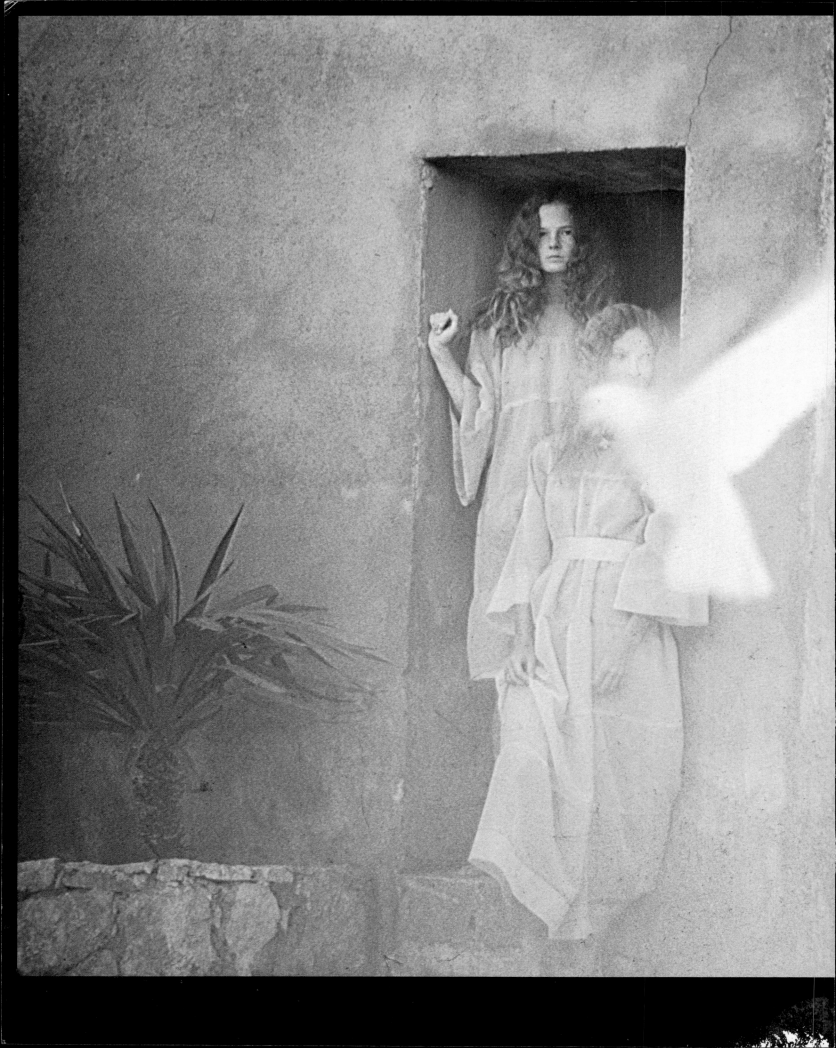

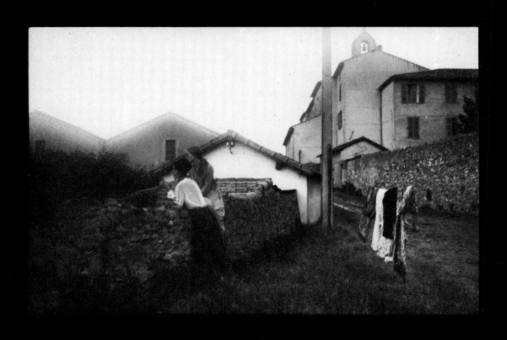

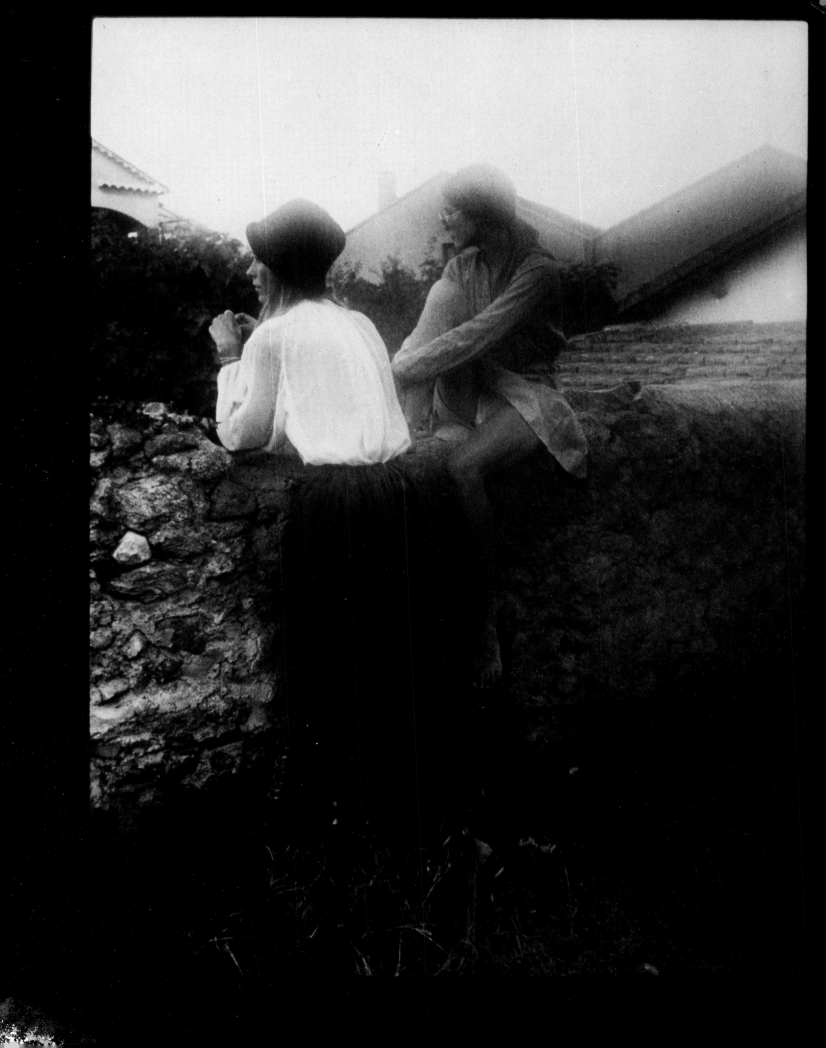

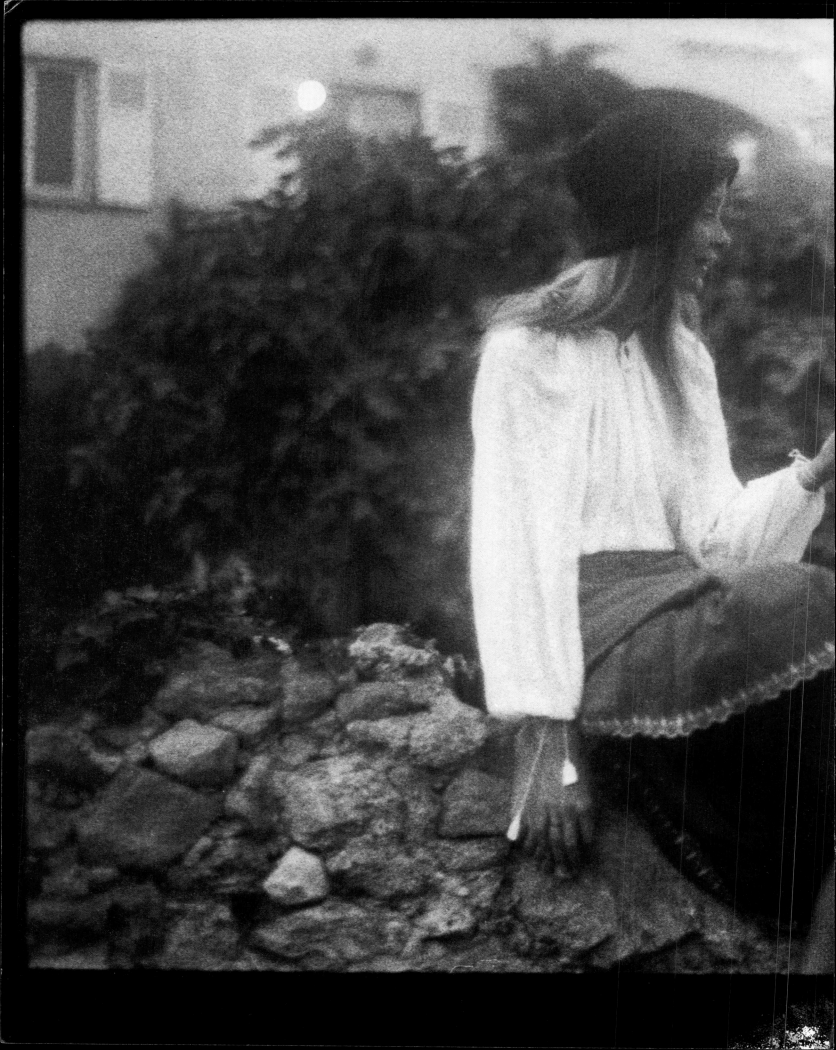

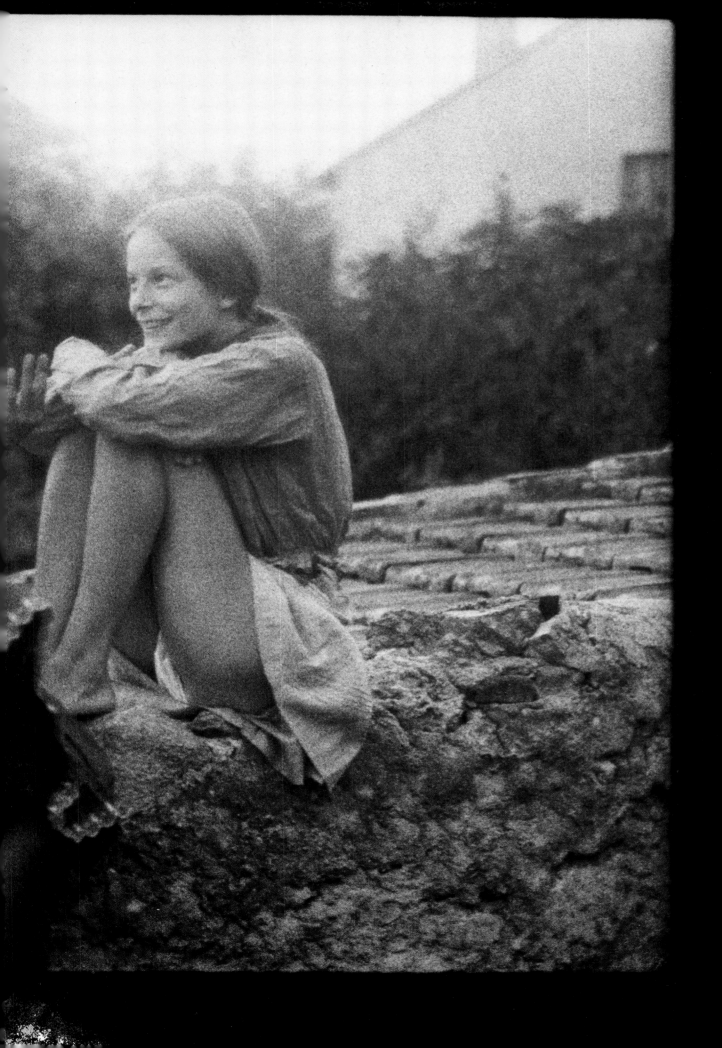

CHARMS OF THE HAREM

To console you, I will now
tell you your true story. Barely are you out of infancy,
when you must be bought by the Sultan
– your parents are too poor to provide for you –
and you are shut up in an obsolete palace, full of
velvets and silks, furs, marble and doors held shut
by locks and chains. The whole day long
you nibble bonbons, languishing on doeskin sofas,
your only companions little curly haired dogs,
perfumed and docile, gorged too on milk,
opium, sweets.
The Sultan is neither old nor cruel. He might even be
considered a kind man; but he is a fool,
like all young men, and you have told him
you no longer want to see him. He has a book brought to you,
in which they only put photographs of young girls
intertwined, more or less unclothed, and always with
straps sliding off shoulders, culottes gaping between the thighs,
all of it accompanied by infantile texts written in a tone
which truly seems out of place to you.
After a while, by going through it over and over again,
you realize that the images are poisoned: as you look,
your will power weakens, your mind grows cloudy,
your body becomes tepid and mellow; your neck especially
is already more sensitive and supple, sinuous, more fragile . . .
It is longer too, no doubt; the skin, finer;
your neck seems sleek and round like that of a swan . . .
And then you recall, suddenly, that on the pretext
of celebrating your arrival,
the Sultan had all his young wives strangled,
for his pleasure, and then his most handsome horses slaughtered.
You turn with a single glance, toward one of the
narrow blocked openings of your prison where a bar
of the iron grill is missing . . .

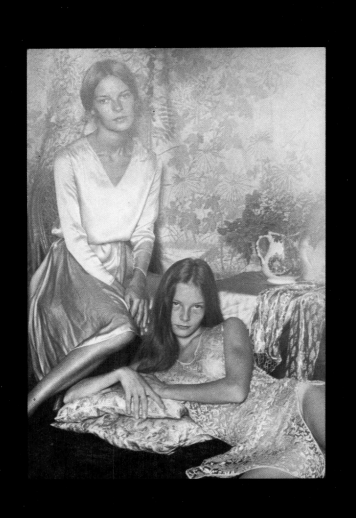

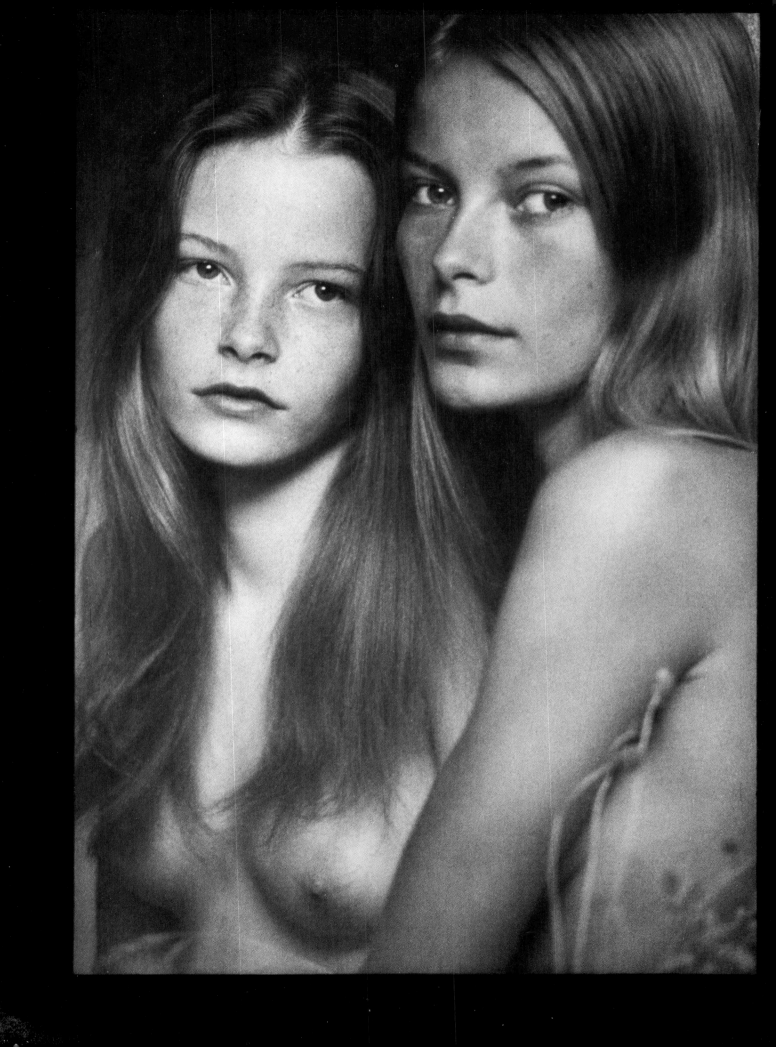

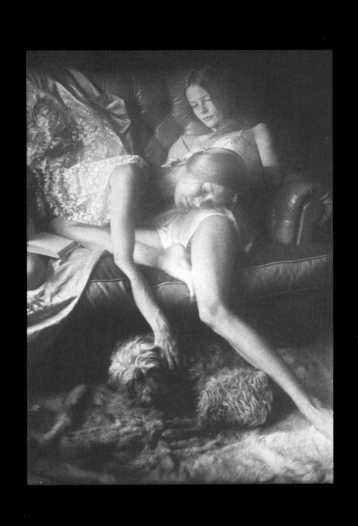

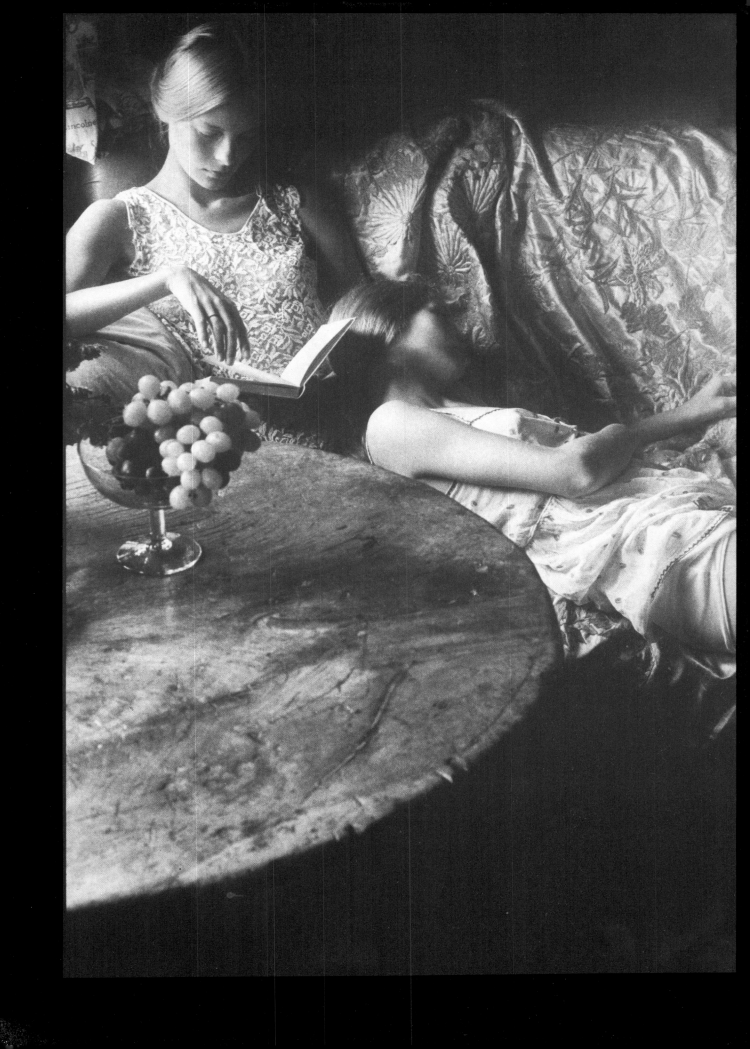

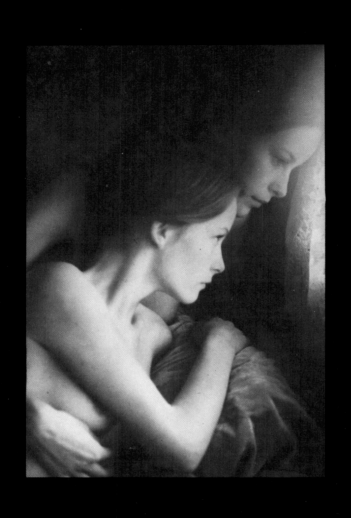

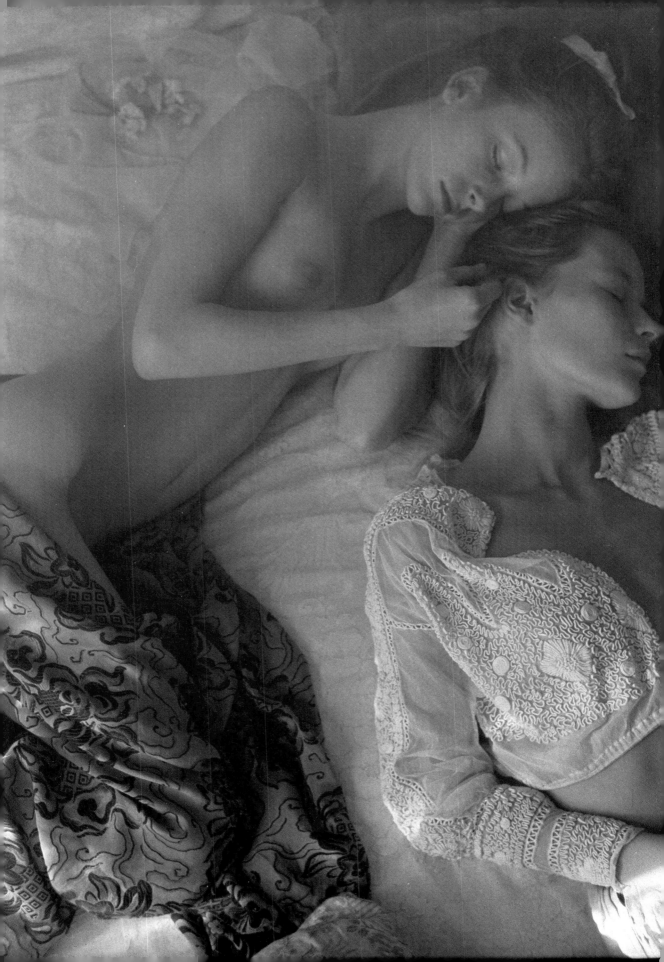

TROUGH
THE MAGIC FOREST

You have escaped through the window.
But the forest surrounding the castle is enchanted, that too:
 the weeds wind around your ankles, over your heads the poisonous plants
 dangling all about you sneer silently,
 the creeping vines hanging down from the branches to grasp
you about the waist, or beneath the arms, by your wrists
 as you pass.
 While bit by bit you lose your breath
 in this mad race, the large red-fleshed flowers
which fall unceasingly from the orchids decorating the giant trunks
 profit from your breathless panting to force their way
 into your half-open mouths, beginning to stifle you.
 Your hair, which has come undone in the struggle,
 is like a tangle of snakes; your torn dresses
 float round your hips
 like immense, bewitched sashes,
 beginning to dance the saraband strangely and
 inexplicably, seeing that there is not
 the slightest breath of air.
 Just at the moment when you might succumb,
 at the end of your strength, you
 finally reach the shore.

The sea! Long before seeing it for the first time, the sea,
I had so often dreamed of it as a child. The sea,
a smooth and tranquil expanse, painted a single blue,
upon which you could run as long as you wished, easily,
not becoming wet. Unlike the water flowing in brooks
and rivers where you must be content to
dip your toes distrustfully (any more than that is
dangerous), you walk on the surface of the sea without
sinking or even leaving the slightest trace;
and you move forward like this, gliding as if in dreams,
experiencing little resistance or fatigue,
toward the horizon,
which is not at all as far as they say.
And then you discover what there is on the other side . . .

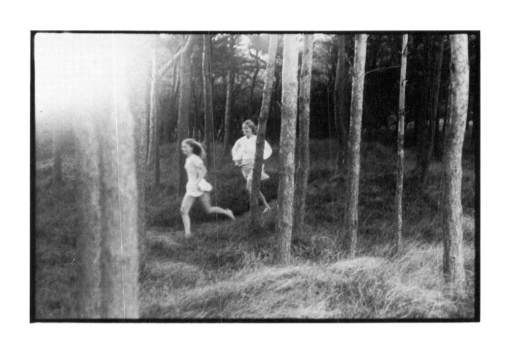

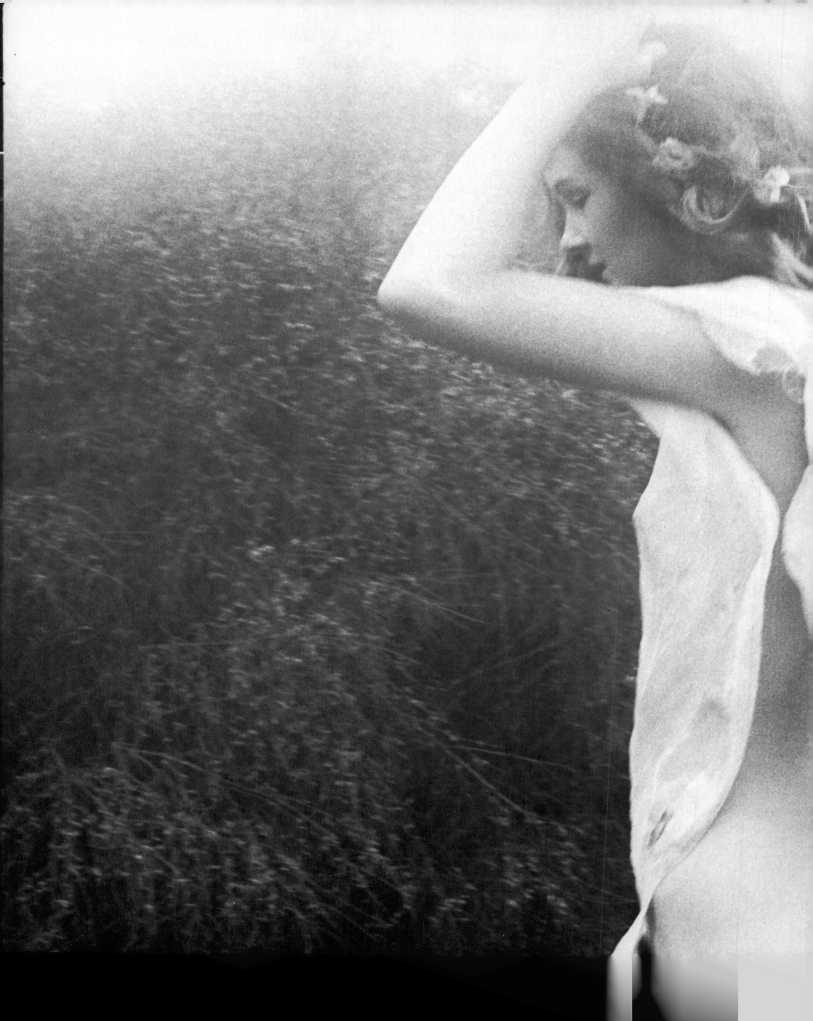

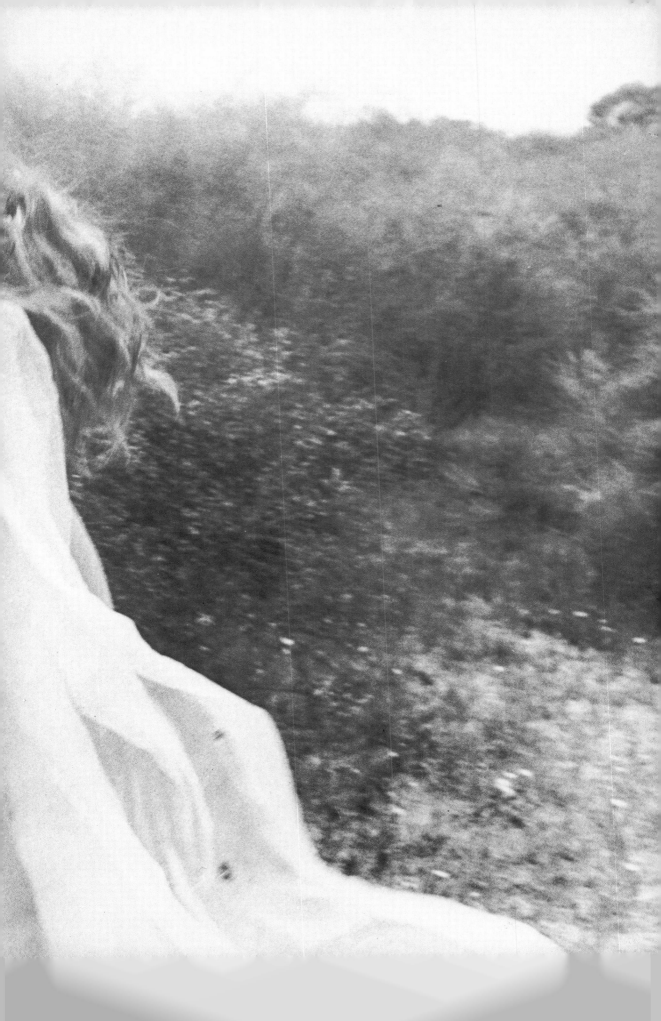

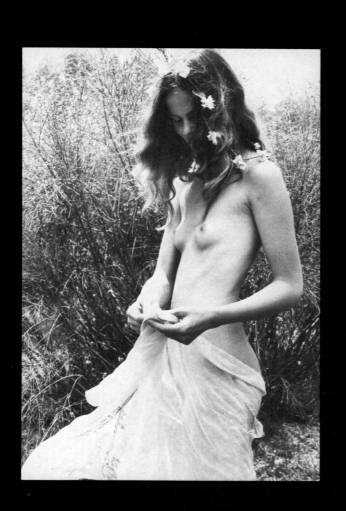

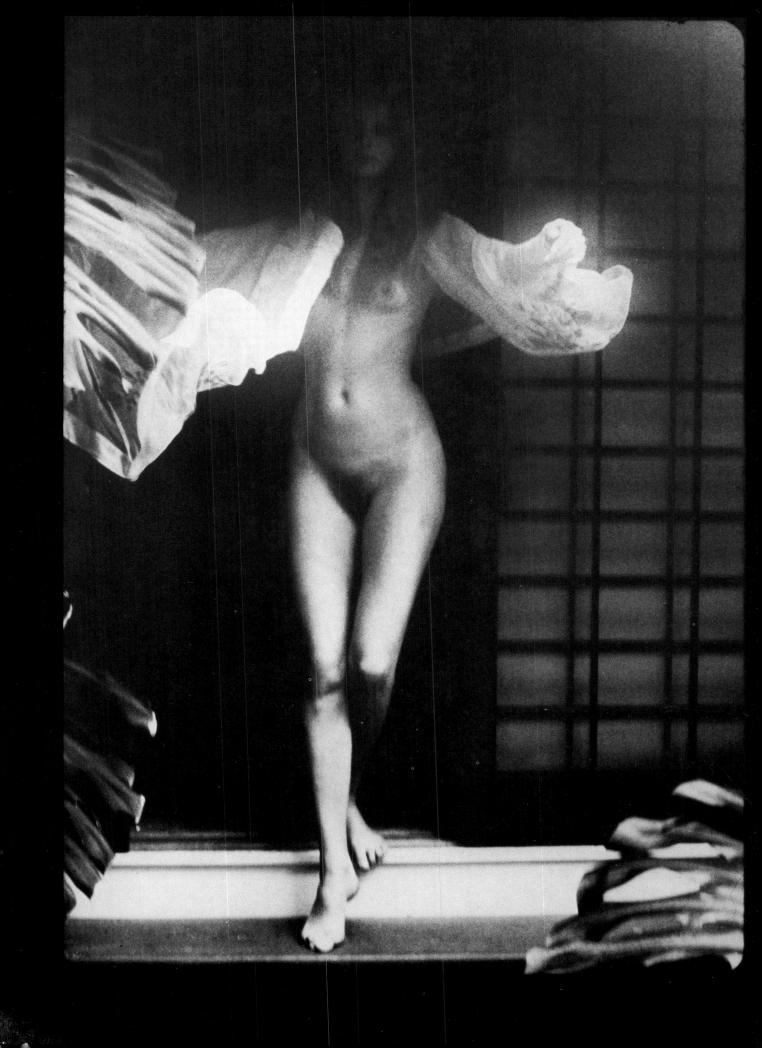

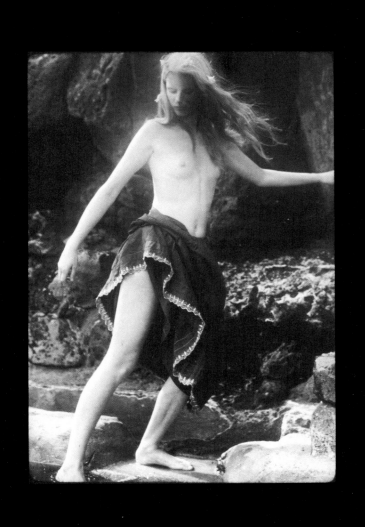

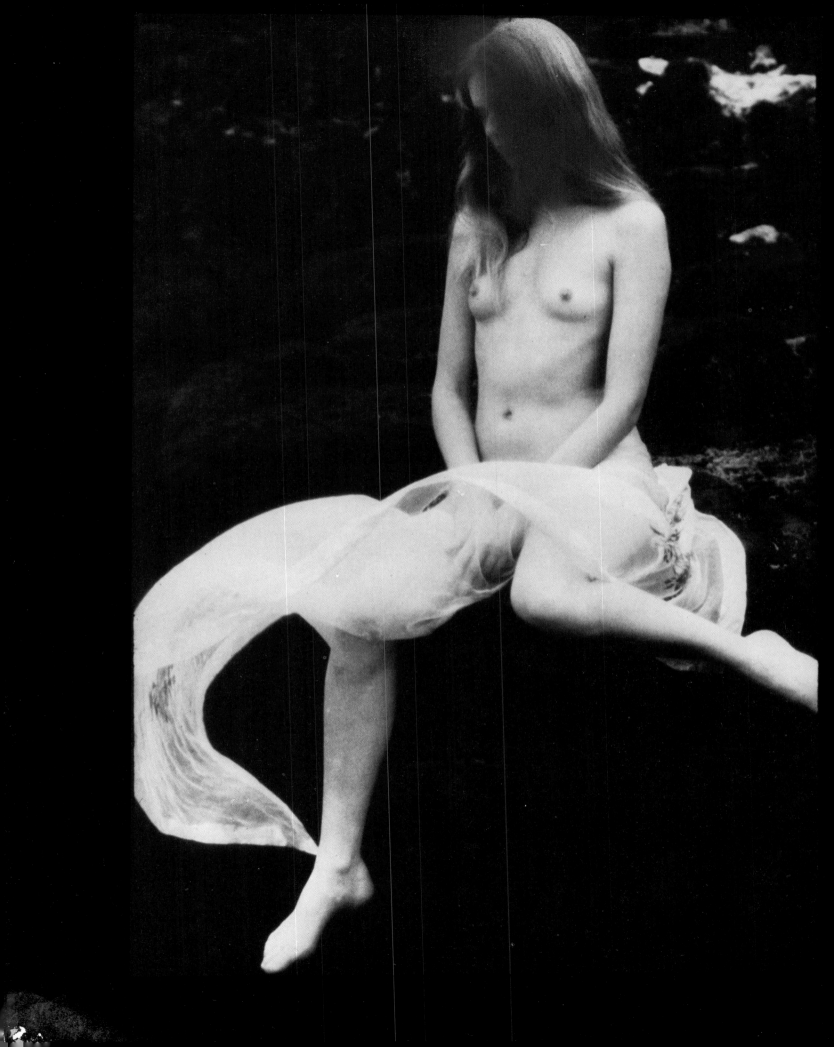

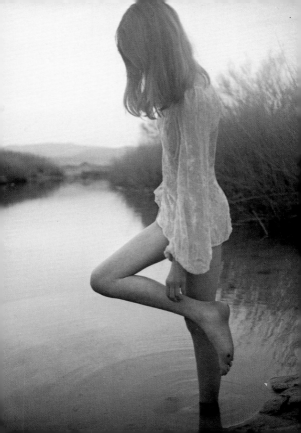

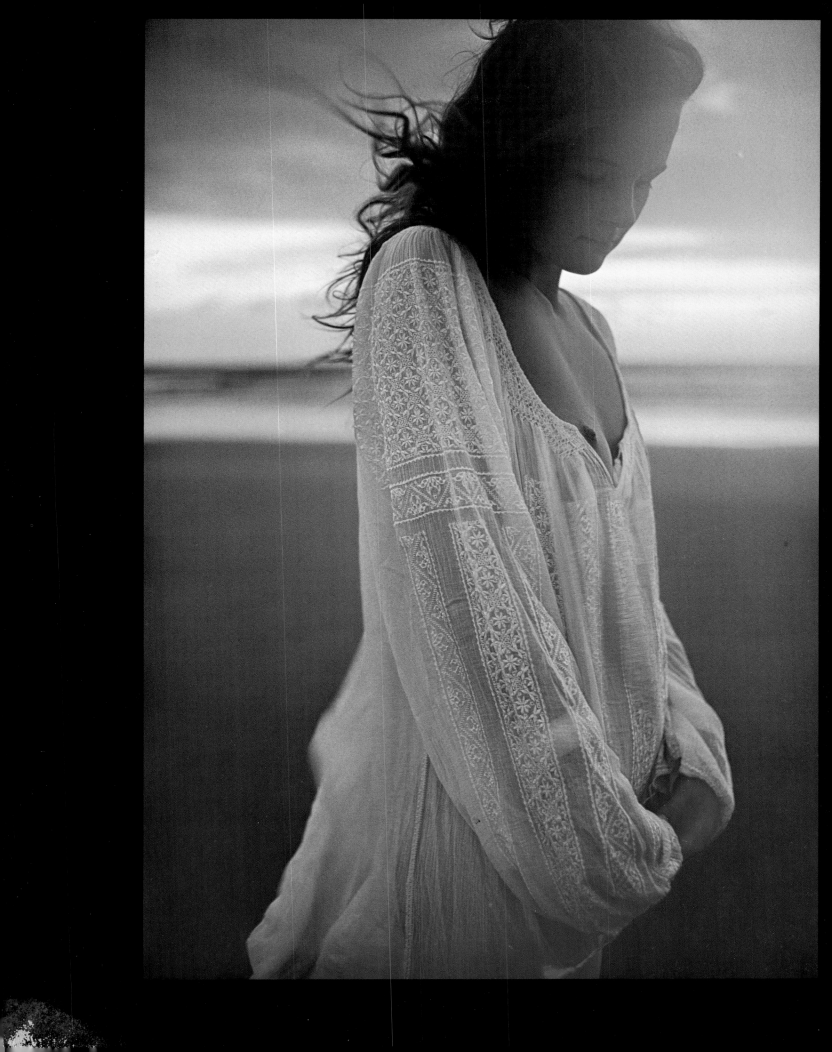

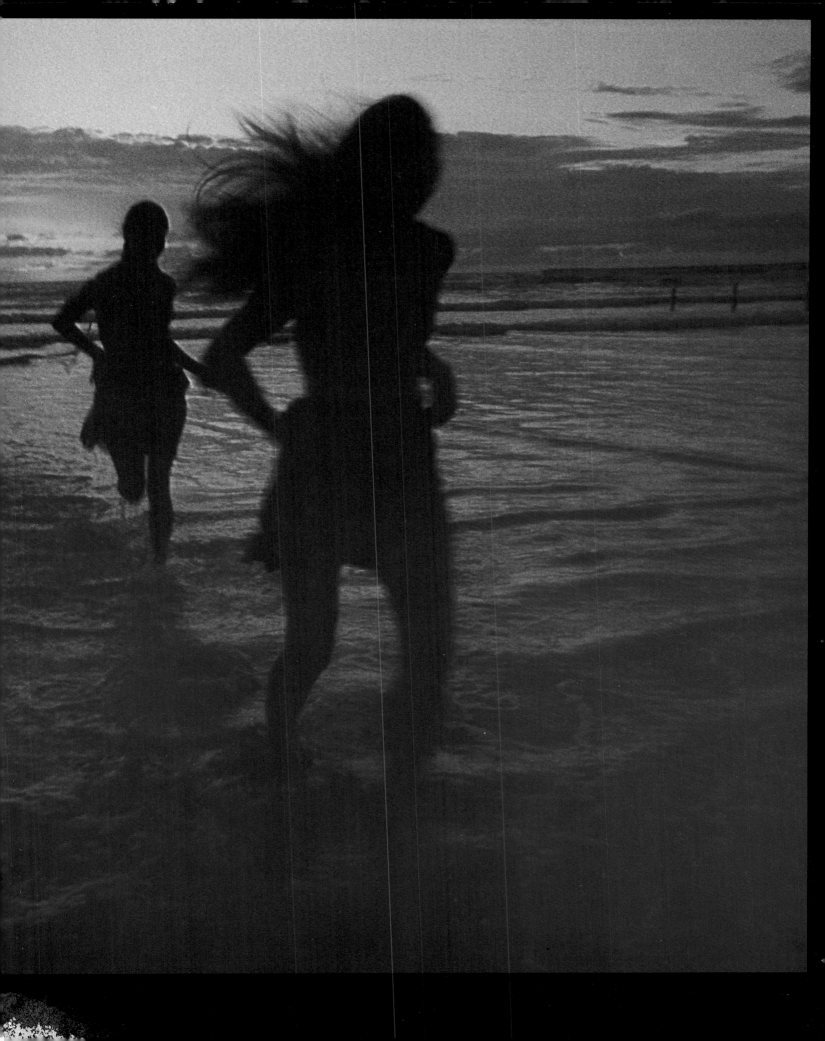

AND NOW LOVE

On the other side, there is the garden
and the house, which have not moved. There they are.

Now you are back home. You have had enough of country parties,
trips, adjectives and metaphors. You tried them
to amuse yourselves;
it was not really so amusing.
You change. You put on old blouses so worn that they
have become transparent, and you do not even bother
to button them. You make chocolate in
big cups. On your skin, here and there, small marks
remain, necessarily; they must be
mosquito bites.

You try to read one of the old books which has lingered in a corner

since I don't know when. And you find it really too stupid . . .

You glance for a second into each other's eyes, as if inadvertently.

You say nothing more and yet, this time,

you know it was said: you are going to sleep together.

There is no one around. It is easy. You pretend suddenly

to be very sleepy; but that is not true, and it

is easy to tell;

it is only not to frighten each other,

and also, to be no longer frightened yourself.

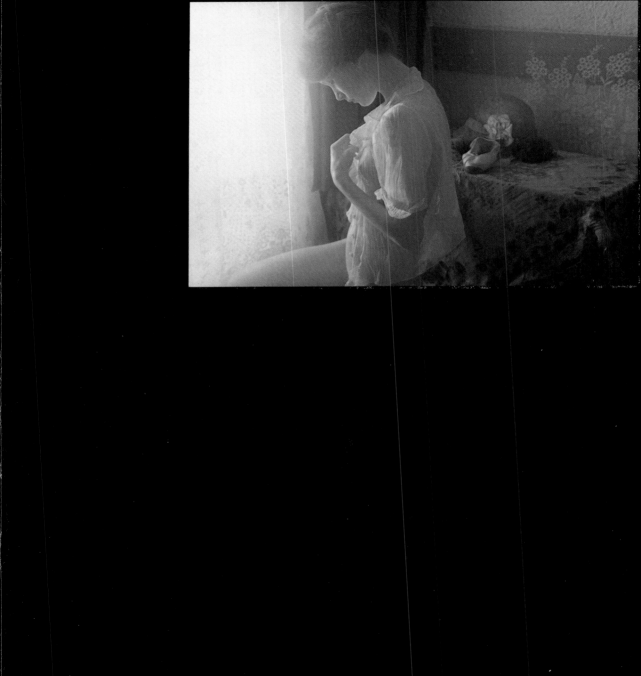

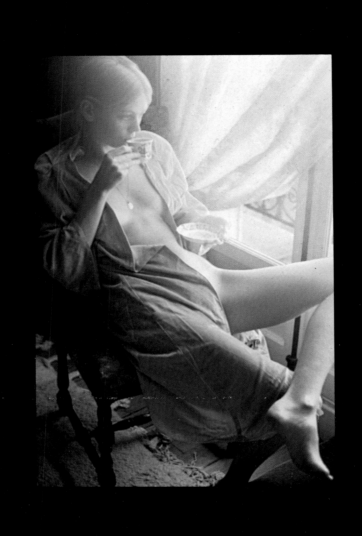

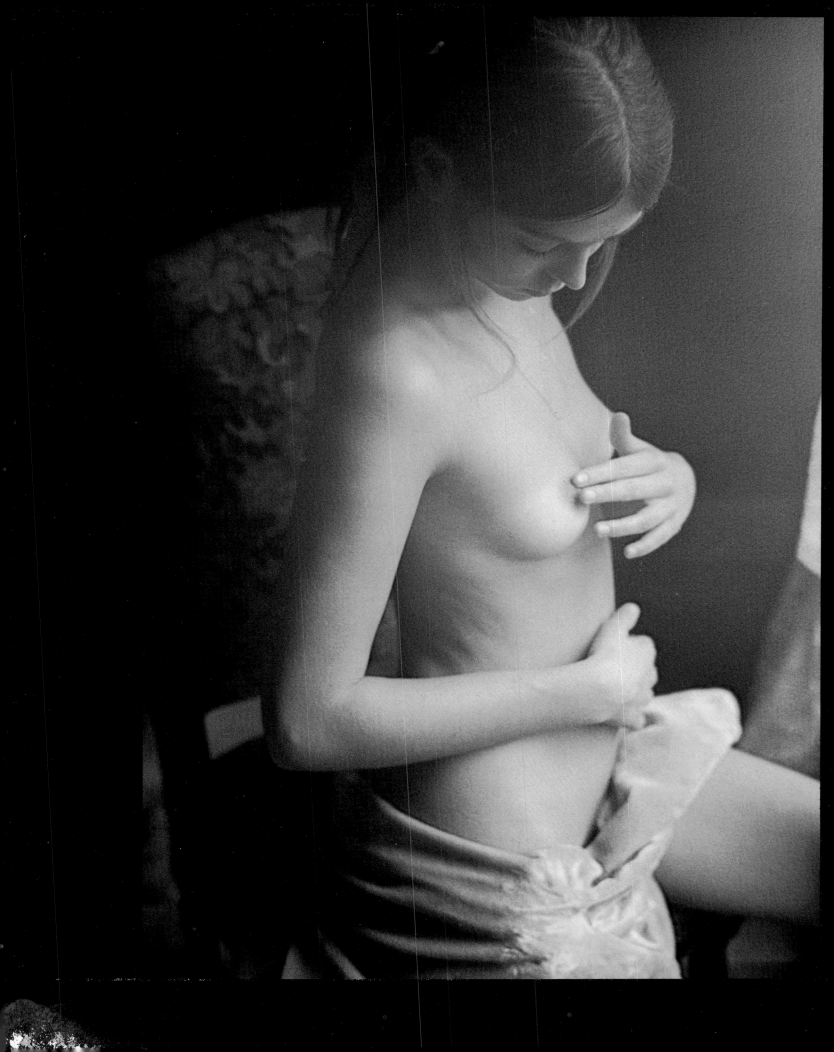

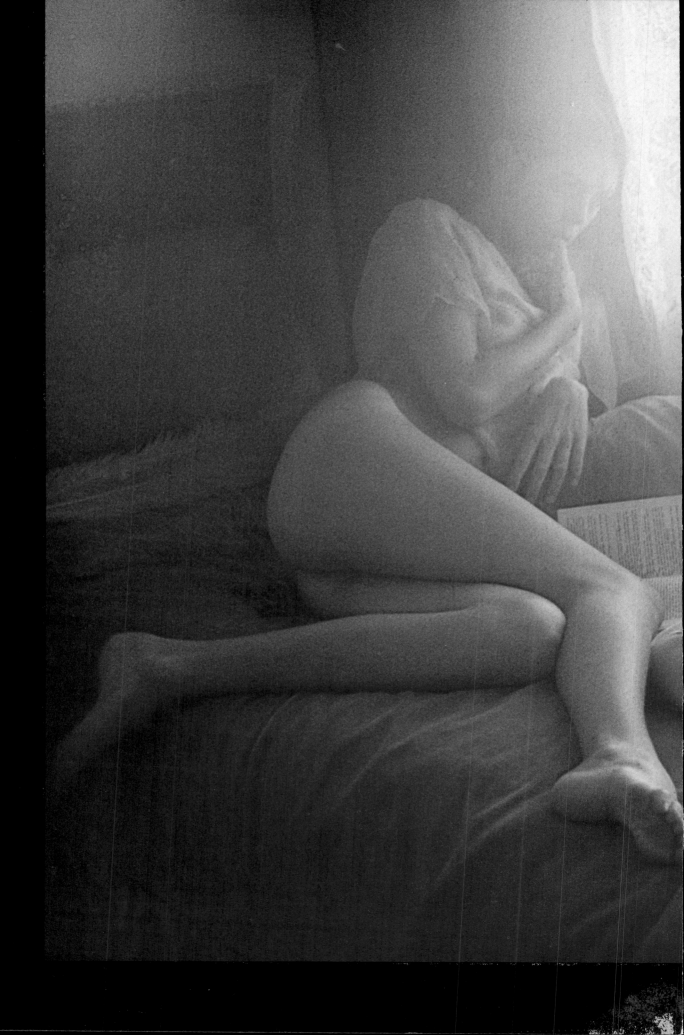

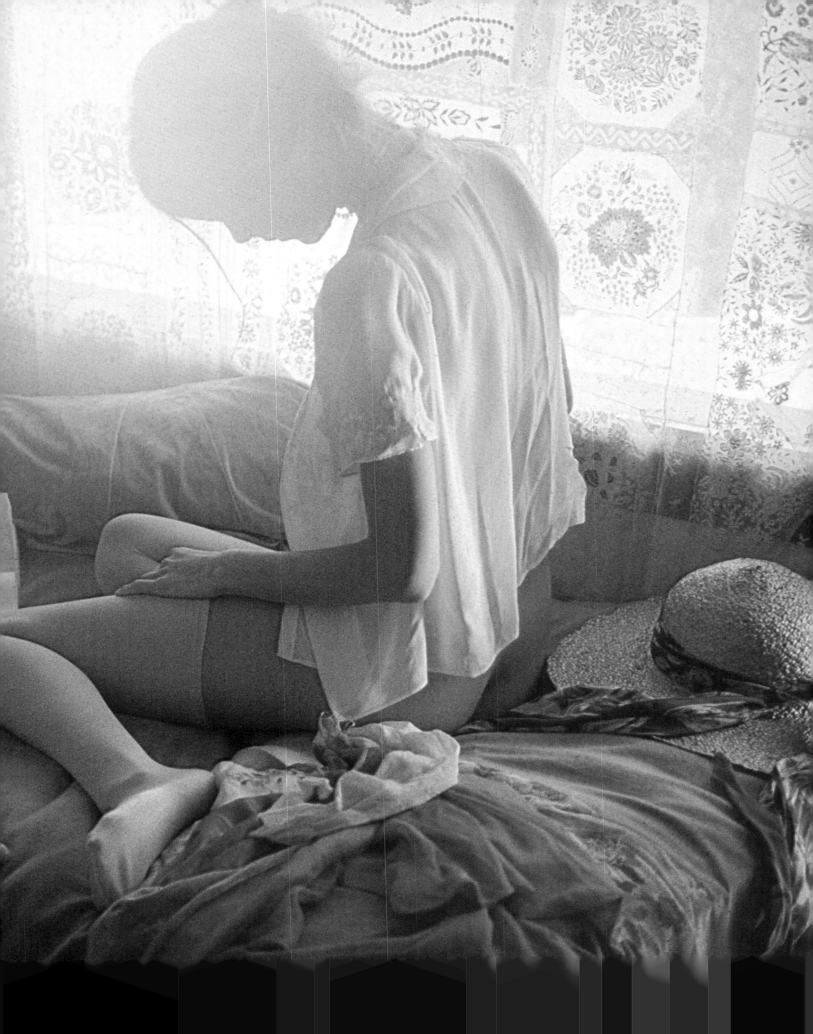

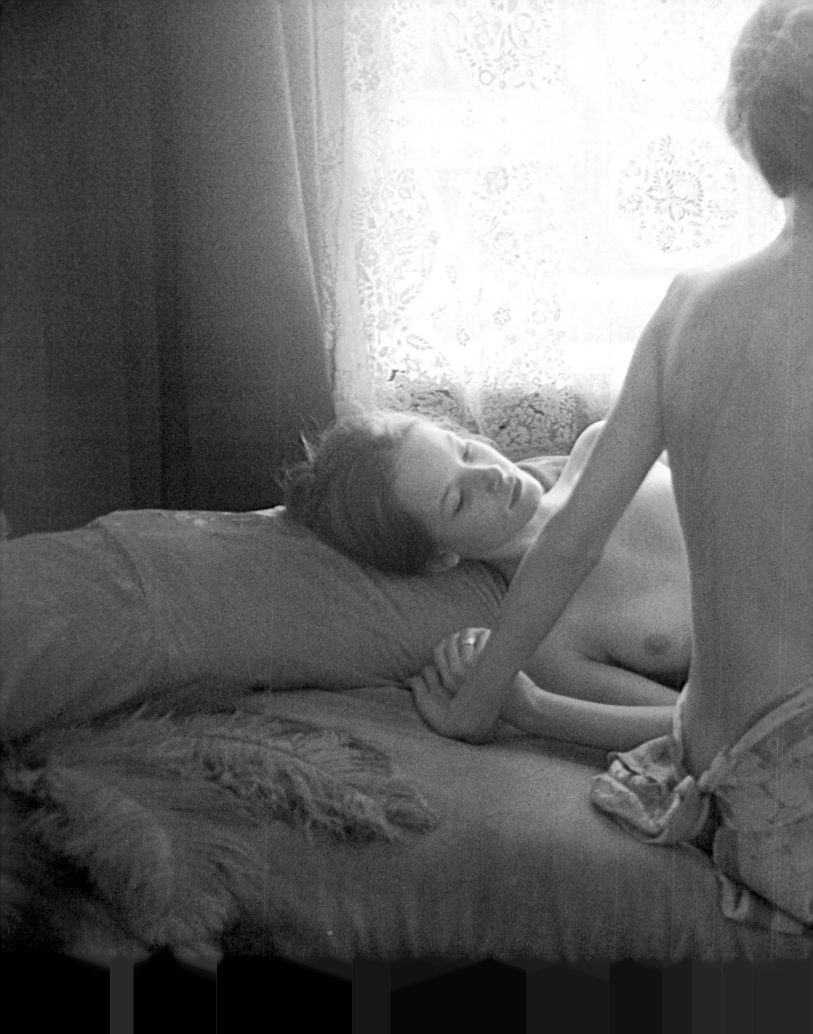

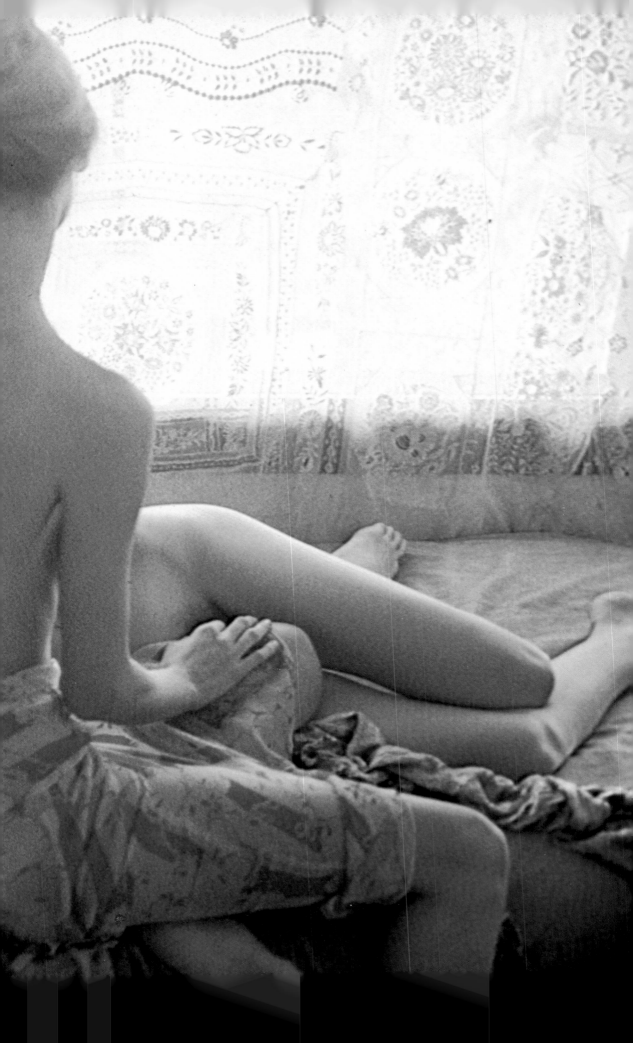

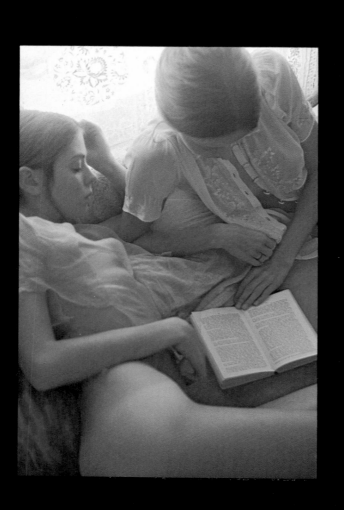

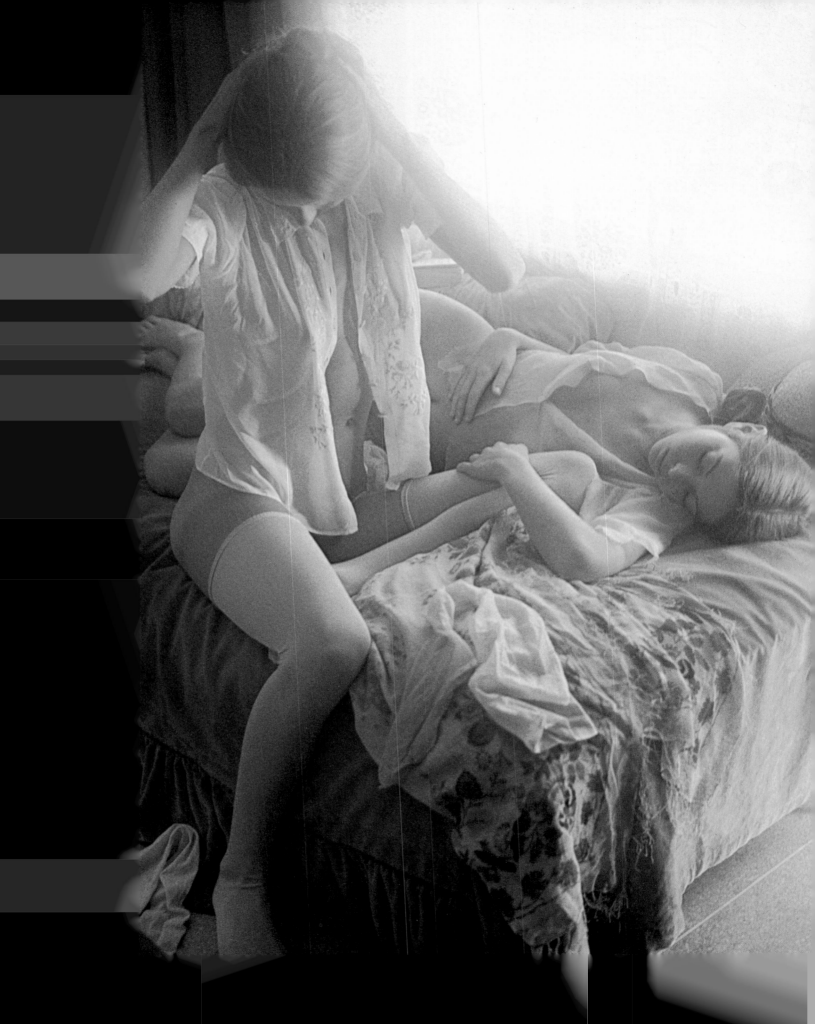

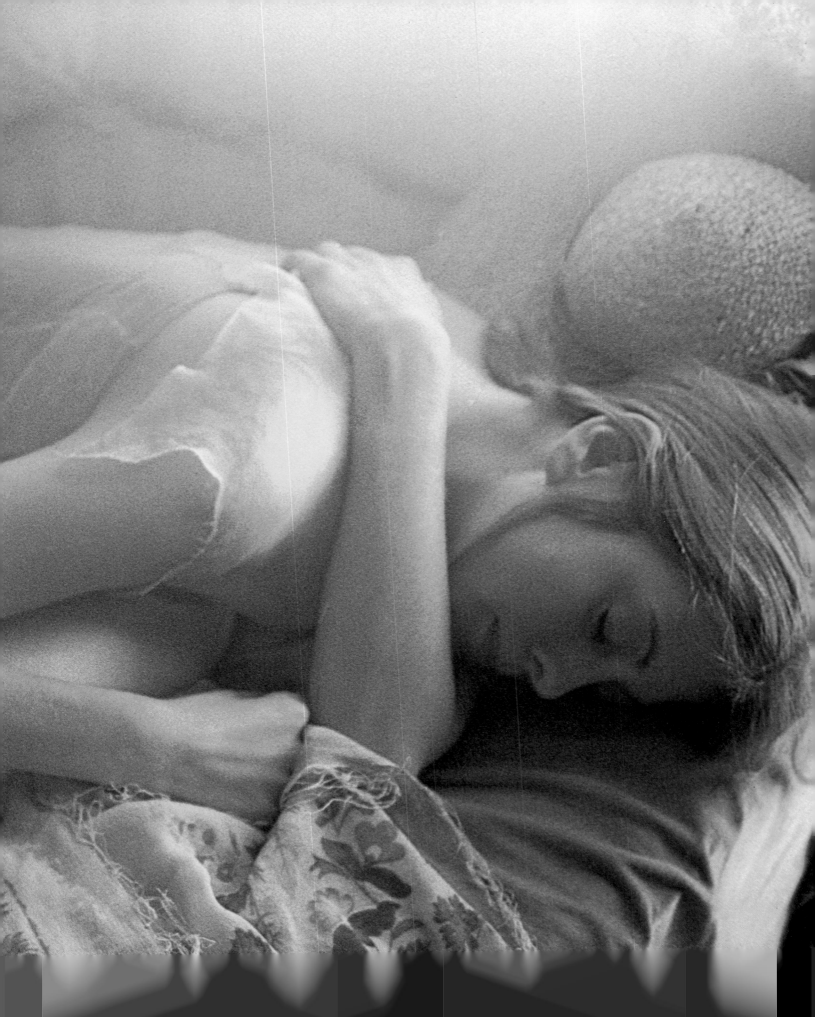

AFTERWARD

Afterward, it is much better, perhaps,
or in any case it is different. The sea which I have often dreamed
of in my childhood: outstretched invitingly, uniform, painted
an intense blue, the freedom to run toward the horizon.
It was also vertical and smooth. It opened in the middle
like a swinging door. And right now, you can dip your feet
into it, look at the bottom, trap shrimps in their holes
and other similar sea creatures, who leave
a funny odor on your fingers, an odor you recognize.

Perhaps you have grown a little older. Now to go out on the sea,
where the horizon always recedes, you must take the little boat
 which is tied to the pier, and lying in your pathway
 is the bicycle from out of the past.

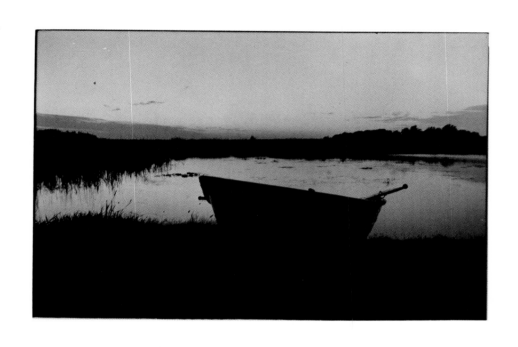

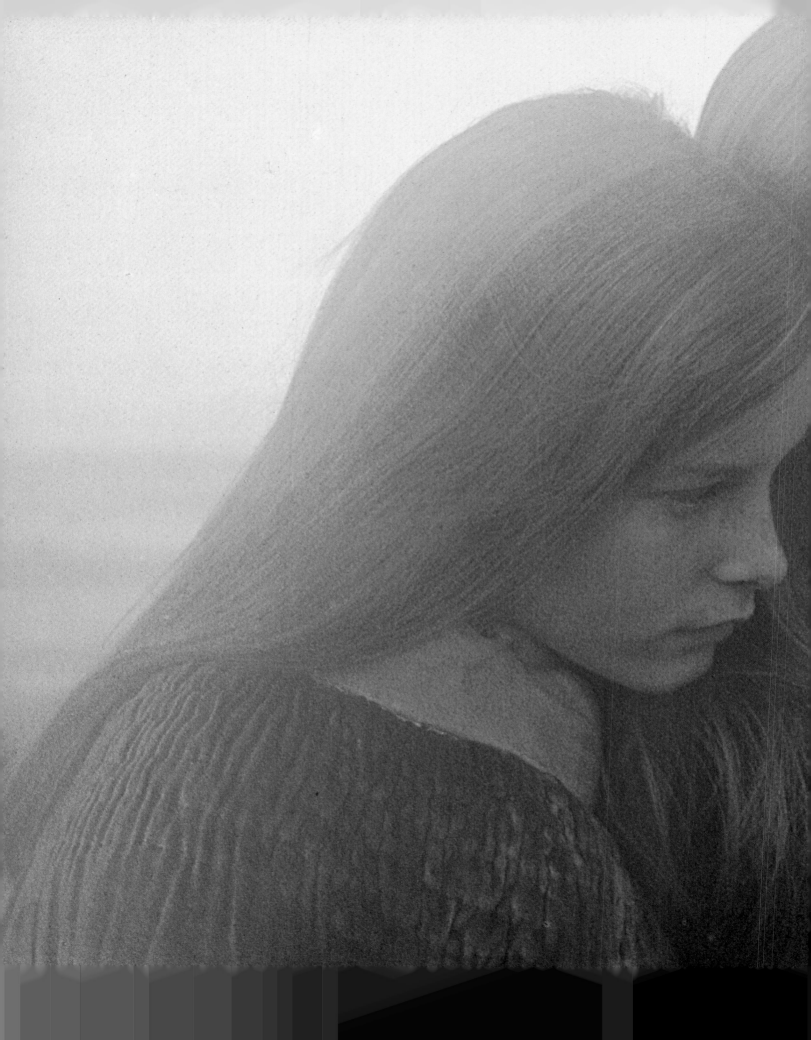

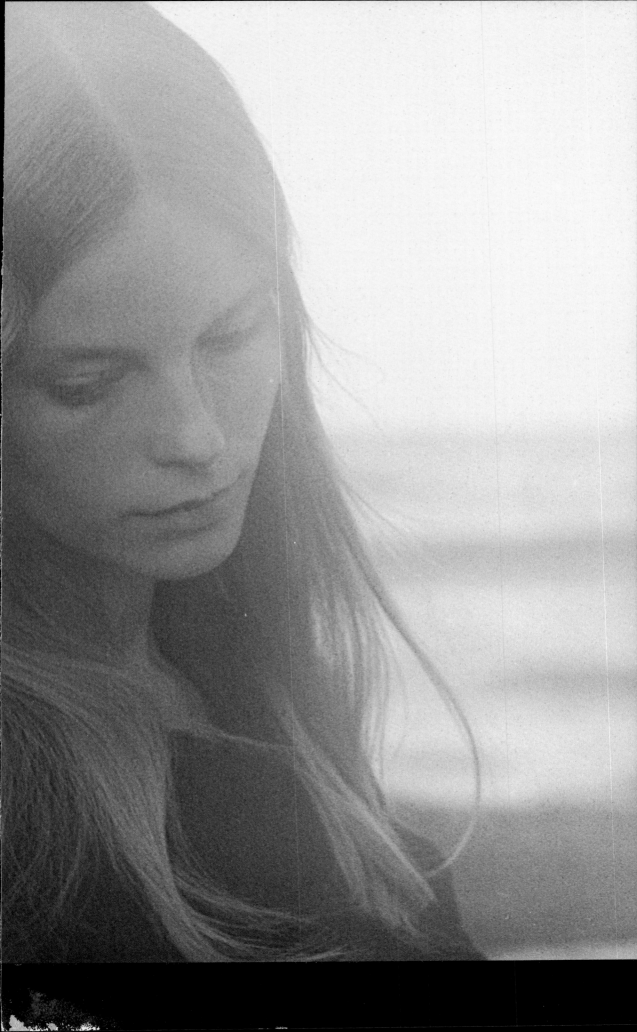

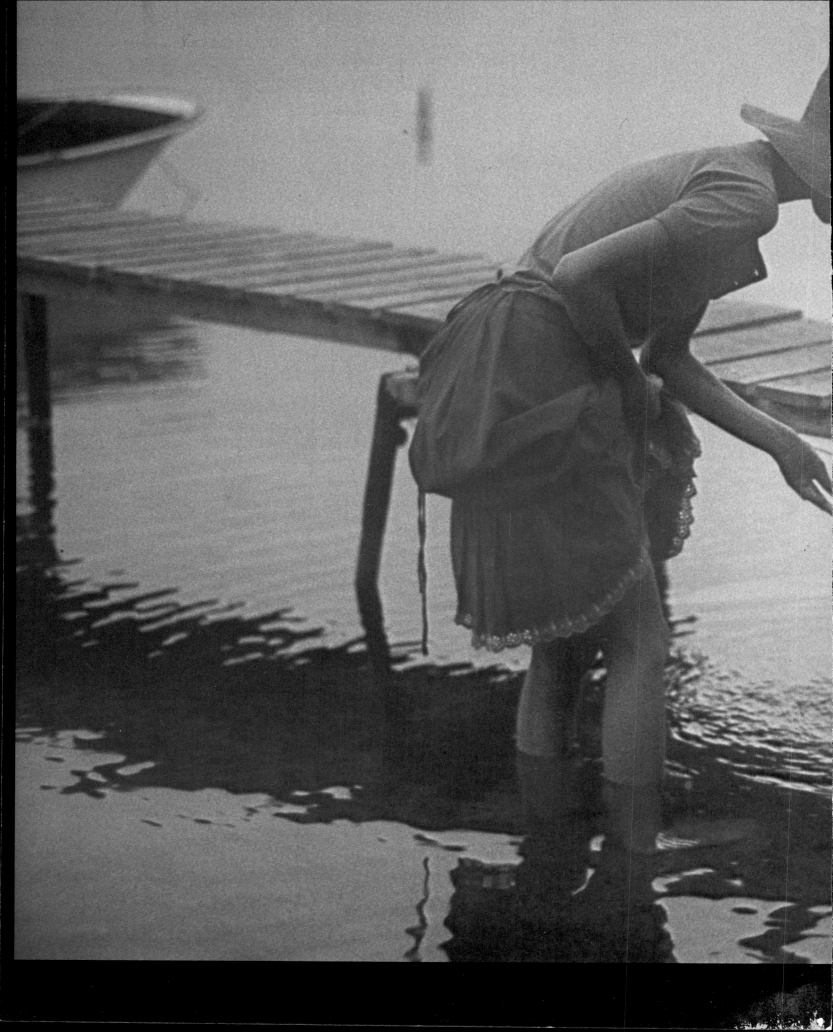

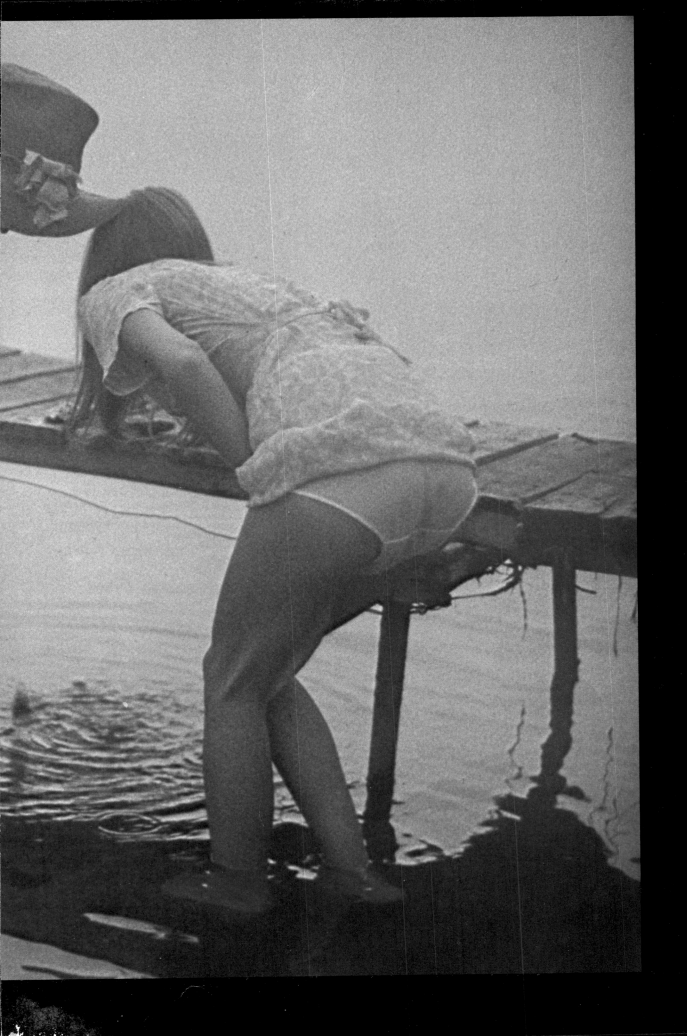

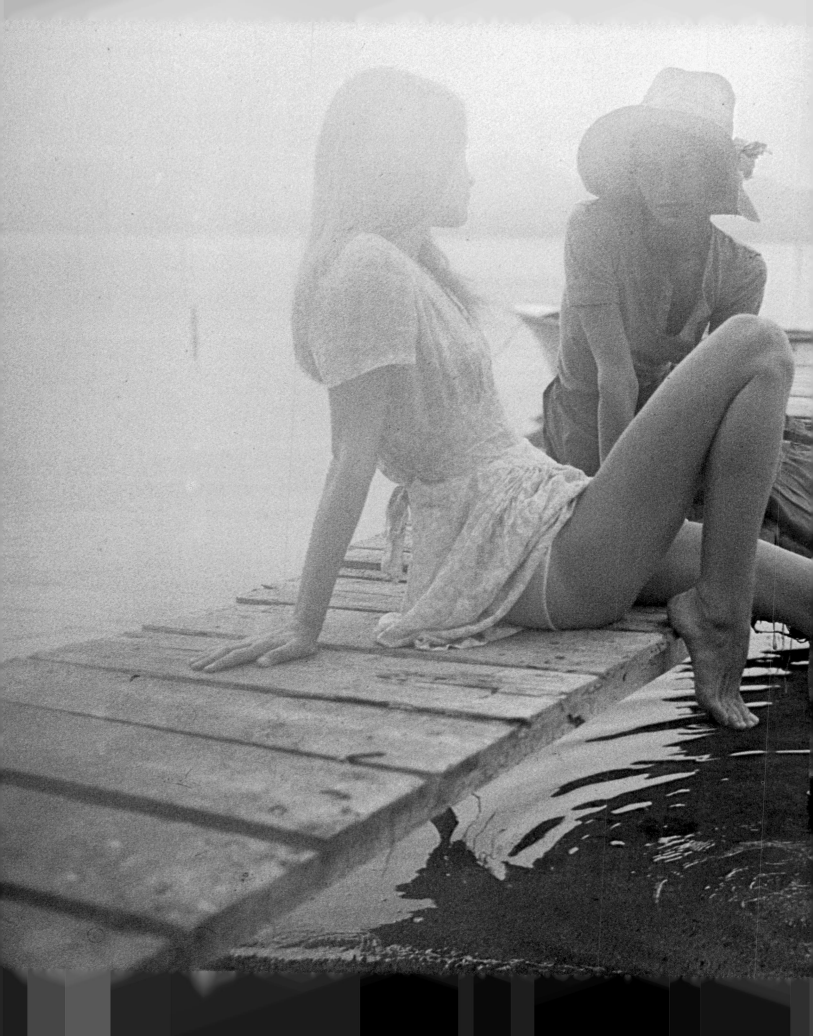

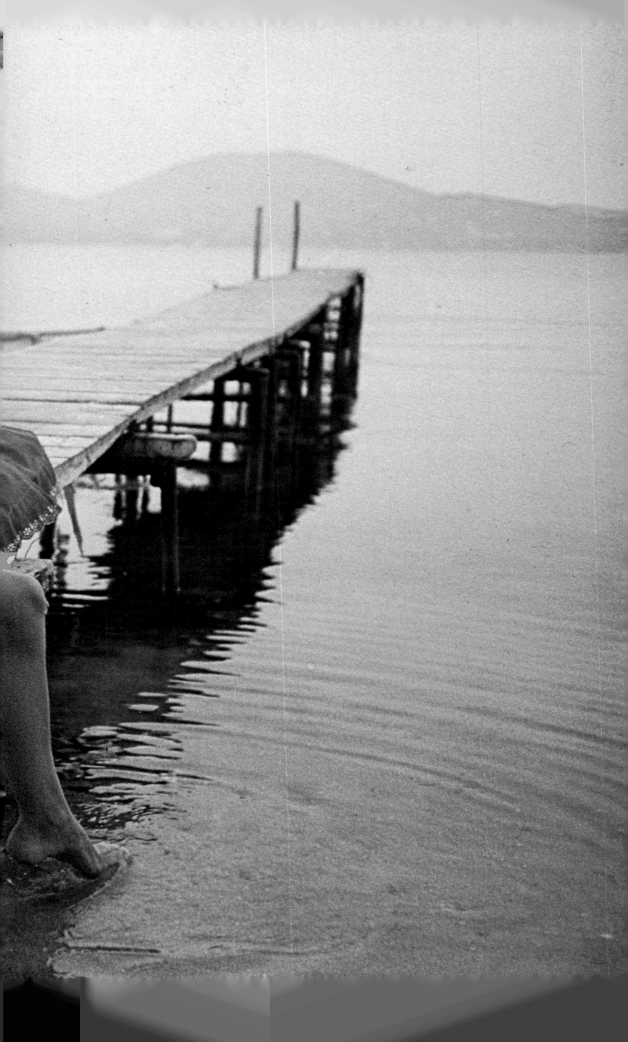

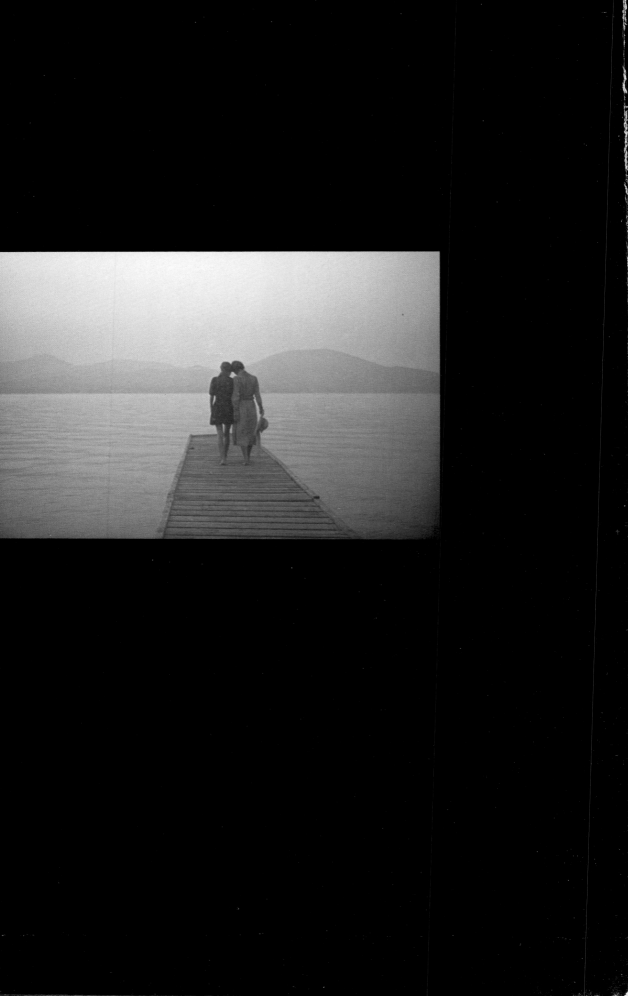

PRODUCTION CONSULTANT: MARITA COUSTET, 3 RUE DES ARÈNES PARIS 5
LAYOUT: MICHEL PAQUET, PARIS
EKTACHROMES: PICTORIAL, PARIS
SEPIA PRINTS: RENAUD MARTINIE, PARIS
WITH THE GENEROUS COOPERATION OF:
PHOTO 3M FRANCE, MINOLTA
MINOLTA CAMERA COMPANY LTD., OSAKA, JAPAN
MINOLTA CAMERA-GMBH, HAMBURG

THIS VOLUME WAS PRINTED AT THE FACILITIES
OF J. FINK DRUCKEREI, STUTTGART, WEST GERMANY,
FEBRUARY MCMLXXIII